THE CHAPELS OF NOTRE DAME

THE CHAPELS OF

LAWRENCE S. CUNNINGHAM

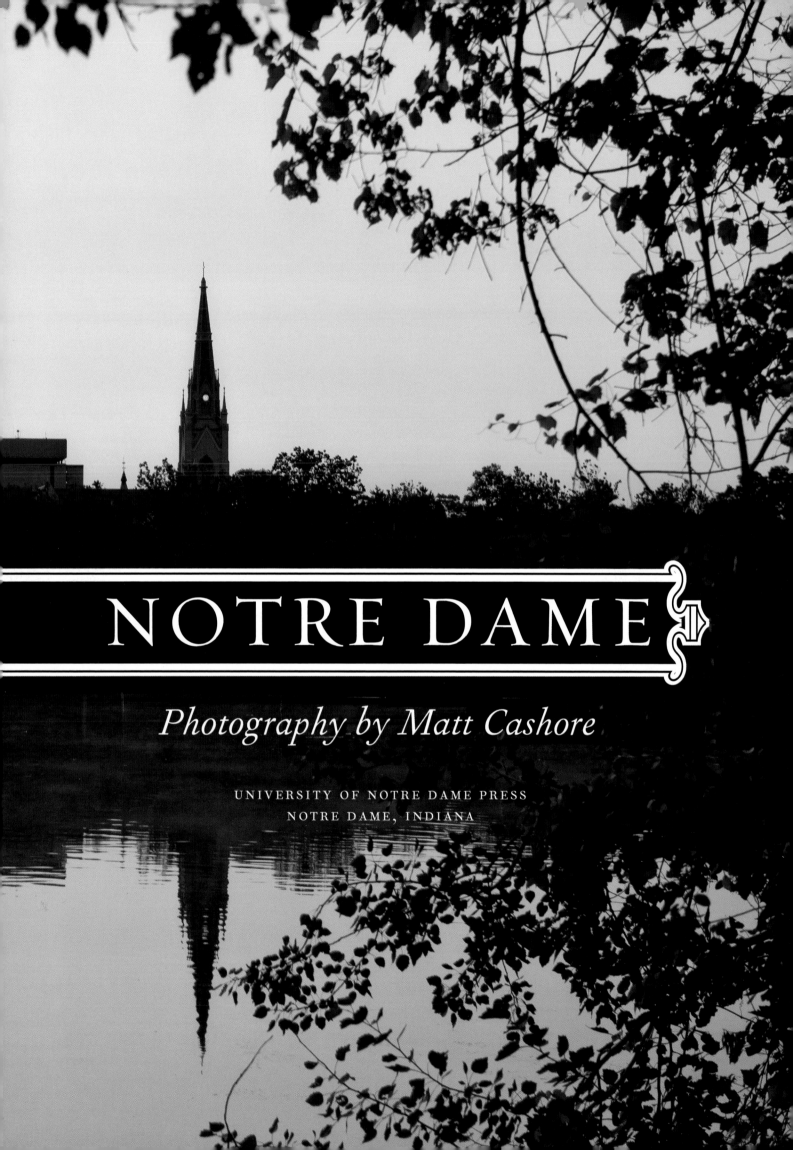

NOTRE DAME

Photography by Matt Cashore

UNIVERSITY OF NOTRE DAME PRESS
NOTRE DAME, INDIANA

Unless otherwise noted, all photographs are by Matt Cashore
and copyright © by the University of Notre Dame

Pictured on the jacket: *front flap*: Statue of the Blessed Virgin Mary atop the Main Building;
front cover: Log Chapel at dusk; *Back cover*: Basilica of the Sacred Heart steeple (*top*)
and Log Chapel interior (*bottom*); *back flap*: Statue of Rev. Edward Sorin, C.S.C.,
founder of the University of Notre Dame
Endsheets: Stained glass portrait of Rev. Edward Sorin, C.S.C., in the Basilica Museum

Design by Ellen McKie; set in 12/14 Fournier; printed by Friesens Corporation

Printed in Canada

Library of Congress Cataloging-in-Publication Data

Cunningham, Lawrence.
The chapels of Notre Dame / Lawrence S. Cunningham ;
photography by Matt Cashore.
pages cm
ISBN-13: 978-0-268-03735-2 (cloth : alk. paper)
ISBN-10: 0-268-03735-3 (cloth : alk. paper)
1. University of Notre Dame—Buildings. 2. Chapels—Indiana—Notre Dame.
I. Cashore, Matt, illustrator. II. Title.
LD4114.5.C86 2012
378.772'89—dc23
2012017206

Printed on paper certified by the Forest Stewardship Council (FSC).

Dedicated to the generations

of men and women who have lived,

prayed, worked, and studied

here in this place. It is these members

of the Notre Dame family

whose prayers, as the psalmist says,

have been lifted up

in these holy places

like the sweet odor of incense.

CONTENTS

Our Lady's University, the University of Notre Dame, has always been unabashedly a Catholic university. On more than one occasion I have described Notre Dame as a place where the Church does its thinking. Catholicism, however, is not purely an intellectual enterprise. It is the tradition within which faith and reason exist in intimate relationship. Part of faith is not simply to profess belief but to confess it in worship. From its very beginnings Notre Dame has been a worshipping community not only at the Basilica of the Sacred Heart in the center of the campus but in the residence halls and academic buildings on campus. Those chapels are a visible sign that expresses our aspiration to create and sustain Christian community. They encourage gatherings for formal worship in the liturgy and are oases of prayer and contemplation before the Blessed Sacrament on an informal basis.

It is striking that the idea for the publication of this book came not from the university's officers nor from its media office but from two couples who were inspired by the beauty of one of our chapels when visiting the campus. Like the ancient psalmist who cried out "I have loved the beauty of thy house, O Lord" (Psalm 26:8), these visitors saw that the chapels on Notre Dame's campus are an integral part of its story. They were so right that their idea was taken up immediately by the university itself. This beautiful volume is the result of that inspiration.

My prayer is that those who page through this lavishly illustrated work will attain a new understanding of the university if they are strangers to it and experience fond memories if they are alumni and friends. May it bring renewed faith to all who, in the words of the liturgy, "make humble prayer and petition through Jesus Christ, your Son, our Lord."

REV. THEODORE M. HESBURGH, C.S.C.
PRESIDENT EMERITUS

Sacred spaces seem to elicit in believers a concrete sense of the communal need for expressions of prayer and devotion. They allow us to step away from the busyness of our everyday lives and to have regular opportunities to put things into perspective in light of our call as Christians who know that we are loved and offered the promise of eternal glory.

Here at Notre Dame, in what John Cardinal O'Hara, C.S.C., once called the "City of the Blessed Sacrament," we have, in addition to the Basilica of the Sacred Heart and Sacred Heart Parish, a plethora of chapels that dot the campus and serve as places of worship for various components of our extended community. Thus, in this extraordinary pictorial display, we can see—in sharp focus—chapels in residence halls, in academic buildings, in Holy Cross community space, in the apses of the Basilica itself, and in a variety of other locations. Together, they are a powerful and recurring manifestation of the University of Notre Dame's deep commitment to its Catholic nature and identity.

Through my years at Notre Dame, I have accumulated, as both worshipper and celebrant, a reservoir of memories connected to many of these same chapel sites—of dorm masses with student participants in every type of formal or informal attire; of prayer services, memorial masses, family baptismal celebrations, retreat conferences, remembrances of the dead at alumni reunions, birthday celebrations, and renewal of wedding vows; of Holy Cross community wake services, faculty and staff prayer for the health and well-being of colleagues and family members, and special masses to begin and end the school year and to enter more fully into the cycle of the liturgical calendar.

Perhaps it is the Grotto that best captures the way in which the sum total of all these sacred spaces represent the spirit of Notre Dame to those who come here to live, work, or study. For it is said that at the Grotto no prayer has gone unanswered, no marriage proposal unaccepted, no search for guidance unresponded to, and no prayer of Thanksgiving unappreciated.

REV. EDWARD A. MALLOY, C.S.C.
PRESIDENT EMERITUS

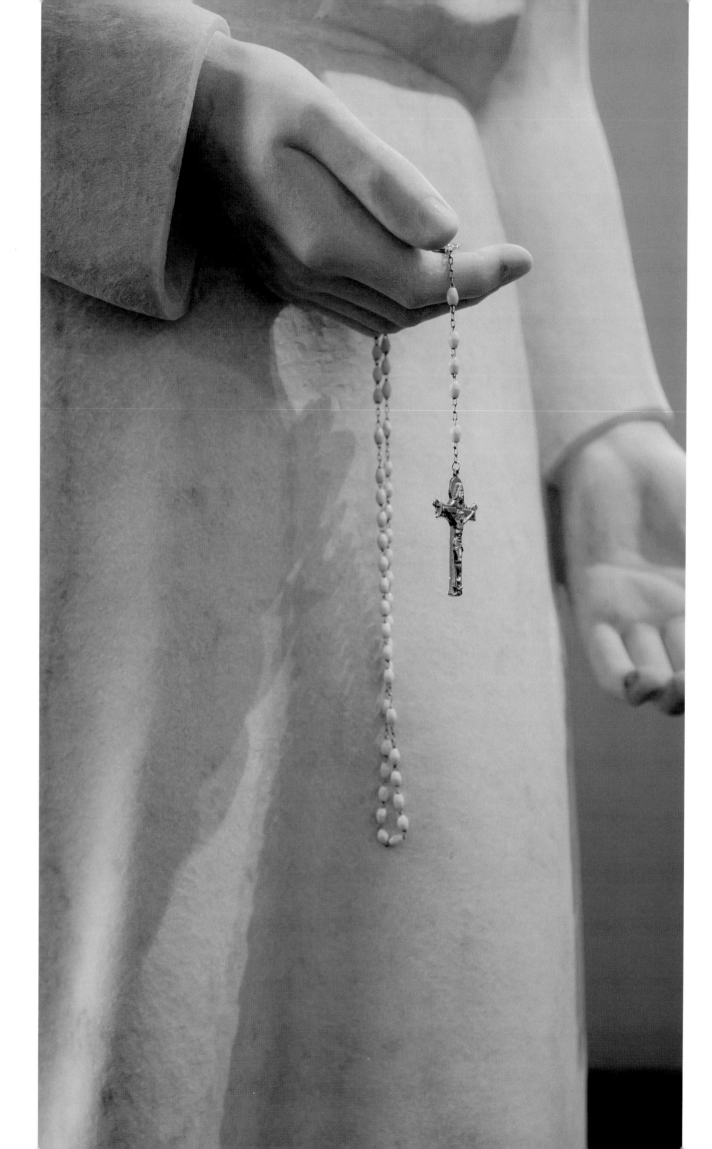

Since its beginnings almost 170 years ago, the University of Notre Dame and the Congregation of Holy Cross that founded it have always emphasized a life of worship and prayer as a hallmark of education. From the building of the rustic Log Chapel to the most recent residence hall chapel, designated places of worship have reminded the Notre Dame family that the love of God is the first commandment. I am absolutely delighted to see this book come to life, because the history of the Notre Dame chapels is a witness to the bedrock conviction that faith expressed in worship is a foundational element of the University of Notre Dame's mission.

The original concept for this book came from two generous benefactors of Notre Dame, Cathy Belatti and Alejandra Segura, who were inspired by Mary after praying the Rosary. After hearing their idea, I had the opportunity to tour all of the chapels on campus and realized that each chapel truly has its own unique characteristics, creating a special liturgical experience. It brings me great pleasure that you will also have an opportunity to personally experience each chapel through this volume.

Moreover, through this work I hope you will gain an appreciation for Notre Dame's commitment to integrating the spiritual, residential, and academic lives of its students. All of the residence halls and several academic buildings on campus have chapels. Hundreds of students volunteer regularly as ministers of music, and during the school year over 150 Masses are celebrated on campus weekly.

Enjoy the guided tour of the most sacred places at Notre Dame. Please be sure to make time to visit some chapels during your next trip to campus.

JOHN F. AFFLECK-GRAVES
EXECUTIVE VICE PRESIDENT

The Rosary

The recitation of vocal prayers and meditations on the mysteries of faith counted on beads is a staple of Catholic devotion. On Notre Dame's campus, the Rosary is recited each evening at the Grotto. The custom of reciting the Rosary goes back to the early medieval period, and the traditional division of the sorrowful, joyful, and glorious mysteries was formulated in the fifteenth century. The beautiful "Hail Mary" is a prayer that combines the angel's greeting to Mary from Luke's Gospel with an added petition that she "pray for us sinners." In 2002 Blessed John Paul II added a new set of mysteries, drawn from the gospels, which he called the "luminous mysteries."

We begin this volume with three chapels, two them freestanding,

all still in use, that date back to the very founding of the

University of Notre Dame. The three chapels are historical markers of

the university's growth. Modest in size, reconstructed in part over the years,

they are a welcome reminder of the pioneering Holy Cross priests and brothers

who first came to this area, settled it with rustic buildings,

and began ministries that continue to the present day.

THE OLD CHAPELS

DATE BUILT:
1855

DEDICATION:
All Souls

ACCESS:
Memorial Day, All Souls Day, and by appointment

> *If we believe that Jesus died and rose, God will bring forth with him from the dead also those who have fallen asleep believing in him.*
>
> I THESS 4:14

The original All Souls Chapel was built in the 1850s under the direction of Brother Francis Xavier, C.S.C., one of the religious brothers who accompanied Rev. Edward Sorin, C.S.C., on his missionary journey to Indiana. After fire nearly destroyed the original building, a new chapel was constructed in 1926. The current All Souls Chapel, with its charming sloped roof and its replica of the original chapel's onion-shaped steeple, reflects the 2004 renovation of the chapel built in 1926. The chapel seats about forty people.

The burial of the dead is one of the seven corporal works of mercy and, as such, the maintenance of Cedar Grove Cemetery is one of the ministries of the Congregation of Holy Cross. Prayers for the dead have always been a part of Catholic piety. Mass is celebrated in this chapel on All Souls Day and Memorial Day, and it is available for funeral liturgies when requested. The cemetery itself is reserved for members of Sacred Heart Parish as well as faculty, staff, and alumni of the university and their families. All Souls Chapel is a concrete reminder of the truth so beautifully expressed in the Eucharistic Prayer of the Roman Canon: "Order our days in your peace, and command that we be delivered from eternal damnation and counted among the flock of those you have chosen."

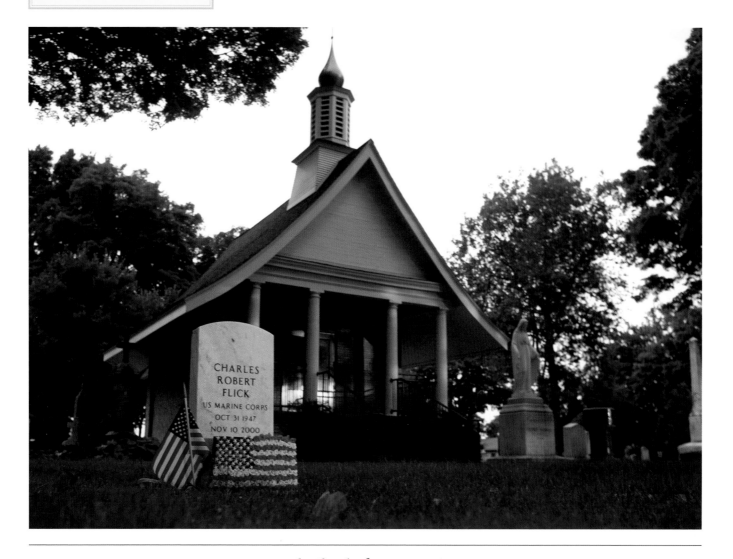

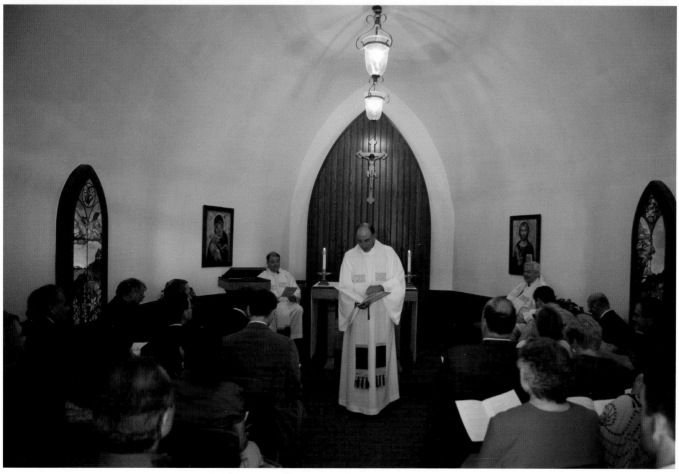

The many who have participated in the baptisms, weddings, anniversary celebrations, prayer services, and other liturgical rites in the Log Chapel may not be aware of how much history stands behind the modest building that long predated the founding of the university. Known as the Indian Chapel, built by Rev. Stephen Badin in 1831, the rough building served as housing for Father Sorin and his Holy Cross brother companions when they arrived in 1842. The original chapel fell into disuse in 1848 (and burned to the ground in 1856), and a replica was constructed in 1906. Historians tell us that its timbers were hand hewn with a broadax by a former slave from Kentucky, William Arnett.

Father Badin as well as three other missionary priests are buried under the chapel; the latter three were originally buried under the Basilica of the Sacred Heart. Much used today and much loved by friends of the university, the Log Chapel represents a history that reaches back to the seventeenth-century missionaries who labored with the Potawatomi, to the founders of the university in the nineteenth century, and includes the many today who find in it a place of spiritual refreshment as well as a locus for their participation in the liturgical and devotional life of the Church.

The Log Chapel is dedicated to Our Lady of the Lake, which echoes the full name of the university: Notre Dame du Lac—Our Lady of the Lake.

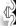

LOG CHAPEL

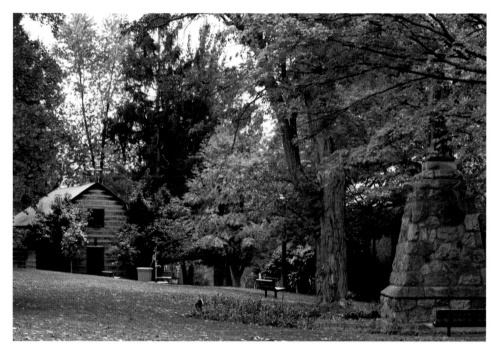

DATE BUILT:
1831

DEDICATION:
Our Lady of the Lake

ACCESS:
By appointment

DATE BUILT:
1843

DEDICATION:
The Holy Family

ACCESS:
By appointment

Blessed in August 1843, Old College is the only extant building that goes back to the early days of Father Sorin and the seven religious brothers who founded Notre Dame. A small, almost rectangular building, it now houses college students who test their vocation for the Congregation of Holy Cross. The students who live at Old College follow the regular curriculum of the university with full participation in undergraduate life expected. For their senior year, they move across the lake to Moreau Seminary for a candidate year before moving on to the novitiate. During their time at Old College, the residents use the chapel for common prayers as well as a location for private prayer and meditation. The Blessed Sacrament is reserved in the chapel. Because the chapel space is small, the residents frequently schedule Mass in the adjacent Log Chapel.

In 1994 the chapel was dedicated to the Holy Family. It is an appropriate title since the Holy Cross Community is under the patronage of the Holy Family: the Holy Cross sisters invoke the Sorrowful Heart of Mary, the brothers invoke the Most Pure Heart of Joseph, and the priests invoke the Most Sacred Heart of Jesus.

The Feast of the Holy Family is celebrated on the Sunday following Christmas unless that day is January 1st.
In such a case, the feast is celebrated on December 30th.

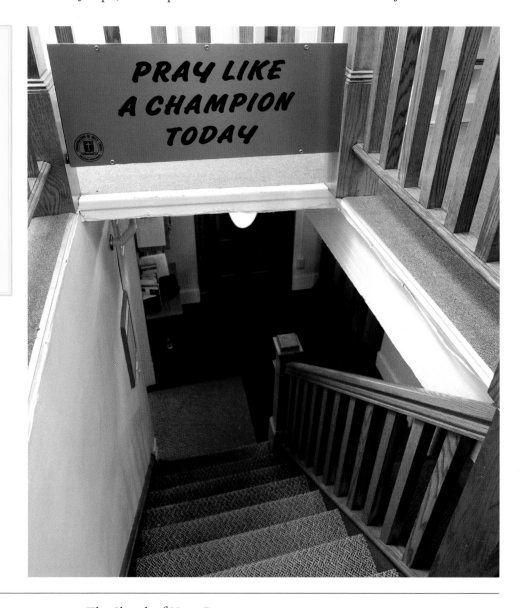

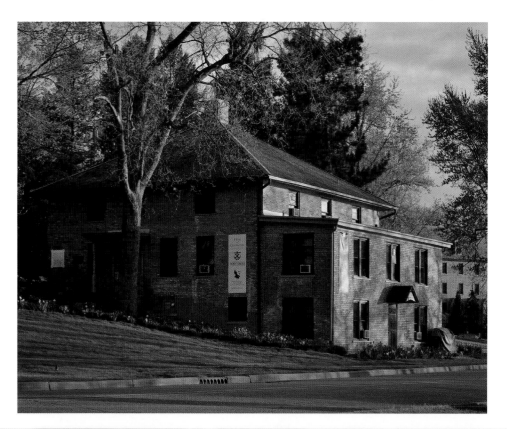

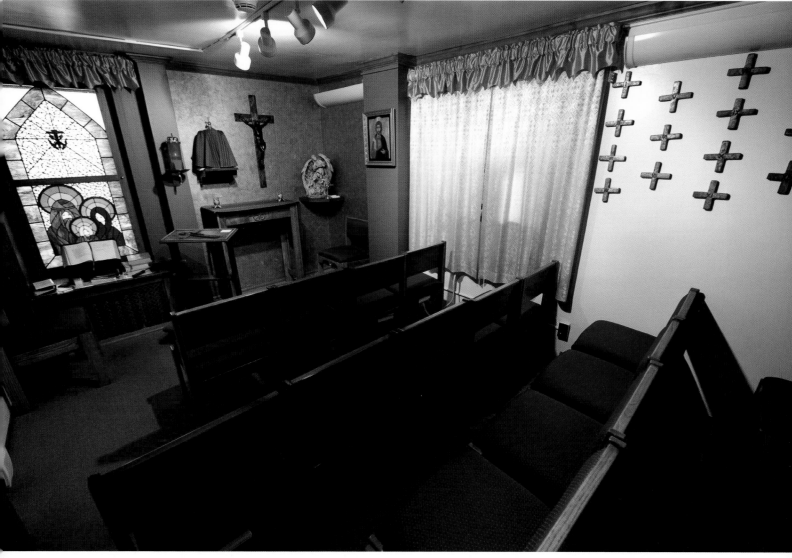

Since the founding of the University of Notre Dame in 1842, members of

the religious community of the Congregation of Holy Cross have lived on

campus. Many of the buildings have undergone change over the years,

but on the campus there are still buildings, each with a chapel, that serve the

brothers and priests in one capacity or another. Many of the chapels are for

private congregational use, but some, either on a special occasion or for other

reasons, are open to anyone invited to share in the prayer lives

of the Holy Cross religious.

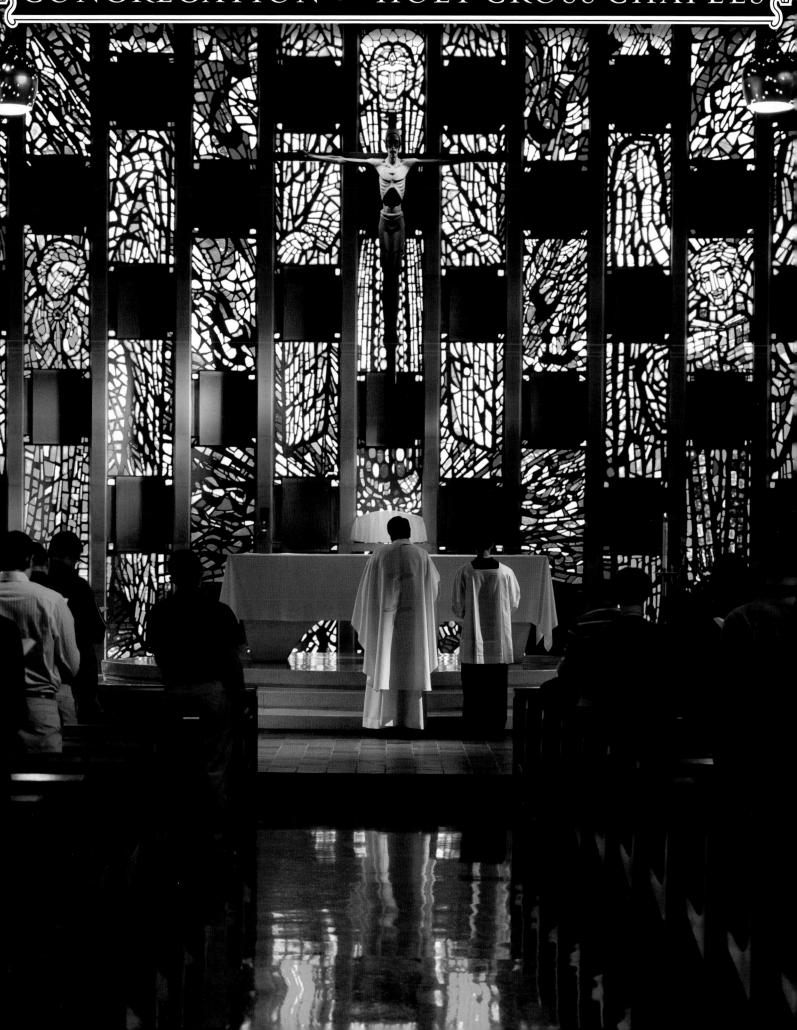

DATE BUILT:
1900

DEDICATION:
Our Lady of Sorrows

ACCESS:
By appointment

Columba Hall, one of the oldest buildings on campus, currently serves as the residence of the Holy Cross brothers. Their chapel is on the third floor of the four-story building. It is used for daily Mass and for the religious exercises of the brothers. On the left side of the main altar is a stunning statue of Our Lady carved in wood. She is depicted with a sword piercing her heart, an allusion to the passage in the Gospel of Luke (2:35) when Simeon tells Mary: "Thy own heart a sword shall pierce." To the right side, flanking the main altar, is a statue of Saint Joseph, the patron of the brothers. On the right side of the chapel is a small altar dedicated to Saint André Bessette with a relic of the saint.

Columba Hall was named for the saintly Brother Columba O'Neill, C.S.C. (1848?–1923). It was once the novitiate of the Holy Cross brothers and later a residence, known as the Community House, for retired Holy Cross priests and brothers.

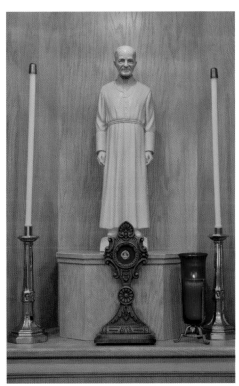

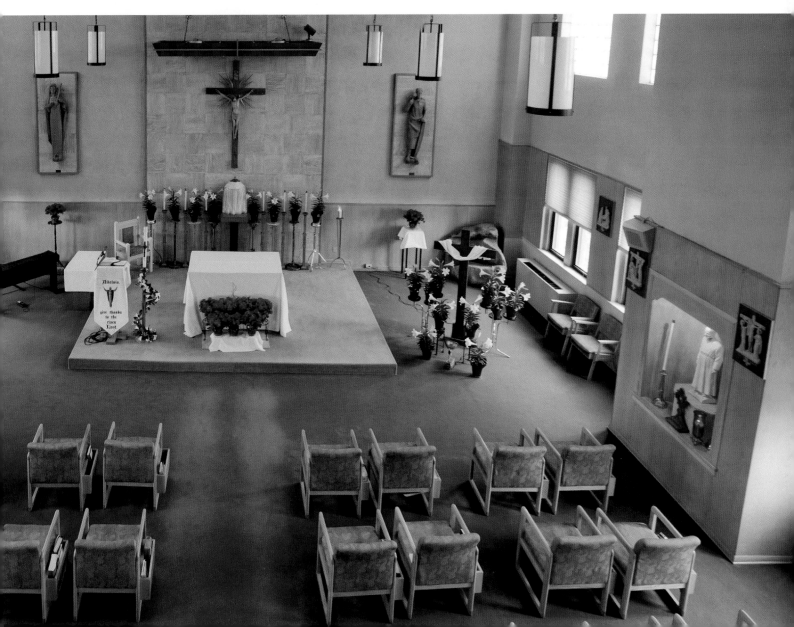

DATE BUILT:
1893

DEDICATION:
Saint Andrew

ACCESS:
By appointment

The Chapel of Saint Andrew, named to honor the memory of Rev. Andrew Morrissey, C.S.C., is on the first floor of the residence and is reserved for the many Holy Cross priests and brothers. The pews are situated facing each other to allow the antiphonal recitation of the morning and evening offices. The original stained glass is still in place (Corby Hall's chapel dates to 1893) with symbols of the passion along the left side and two windows on the right side depicting the Ten Commandments and the symbol and motto of the Congregation of Holy Cross. On the back wall (left side) is a stunning bronze bas-relief of the Sorrowful Mother created by the late Rev. Anthony Lauck, C.S.C.

Saint Andrew's feast day is November 30th. He is often depicted with a so-called "saltire cross," which has the shape of a large X.

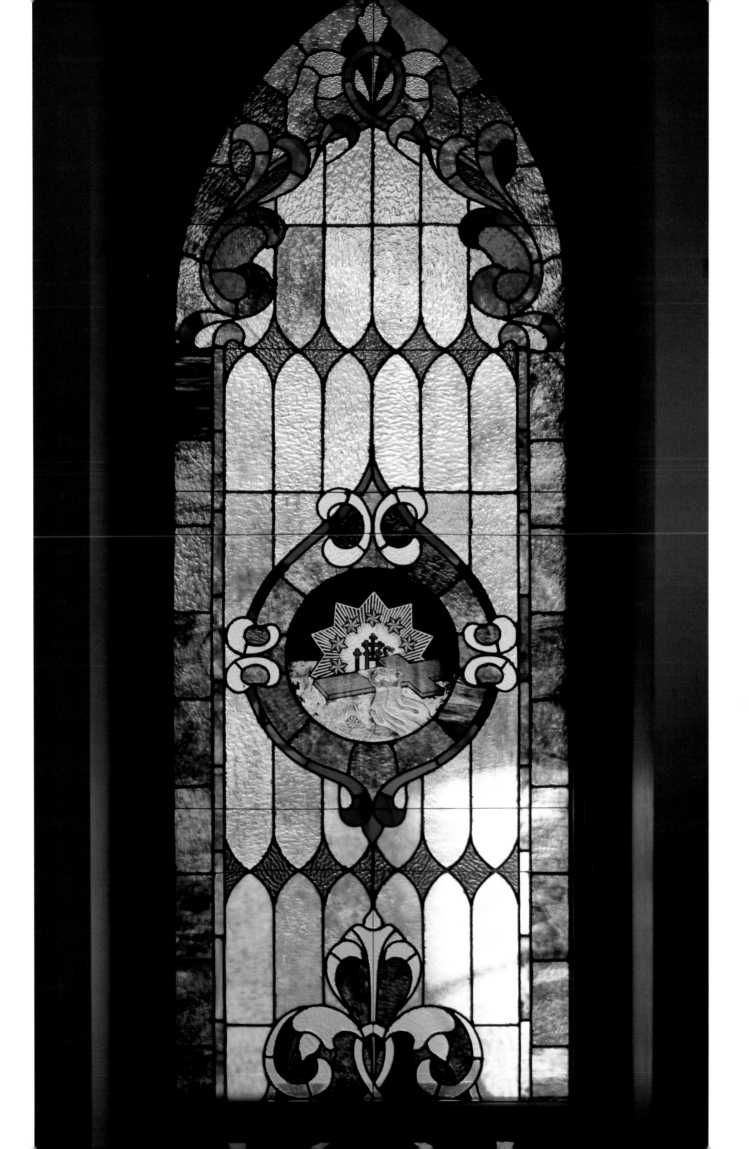

The symbol of the Congregation of Holy Cross features a stylized cross that flowers out at the bottom as anchors. In early Christian art, especially in catacomb art, the anchor was a kind of disguised cross. The anchor in C.S.C. iconography alludes to the affirmation that "we have this hope, a sure and steadfast anchor of the soul..." (Heb 6:19) and illuminates the Congregation's motto Spes Unica—Our Only Hope. That hope, of course, is the saving power of the cross.

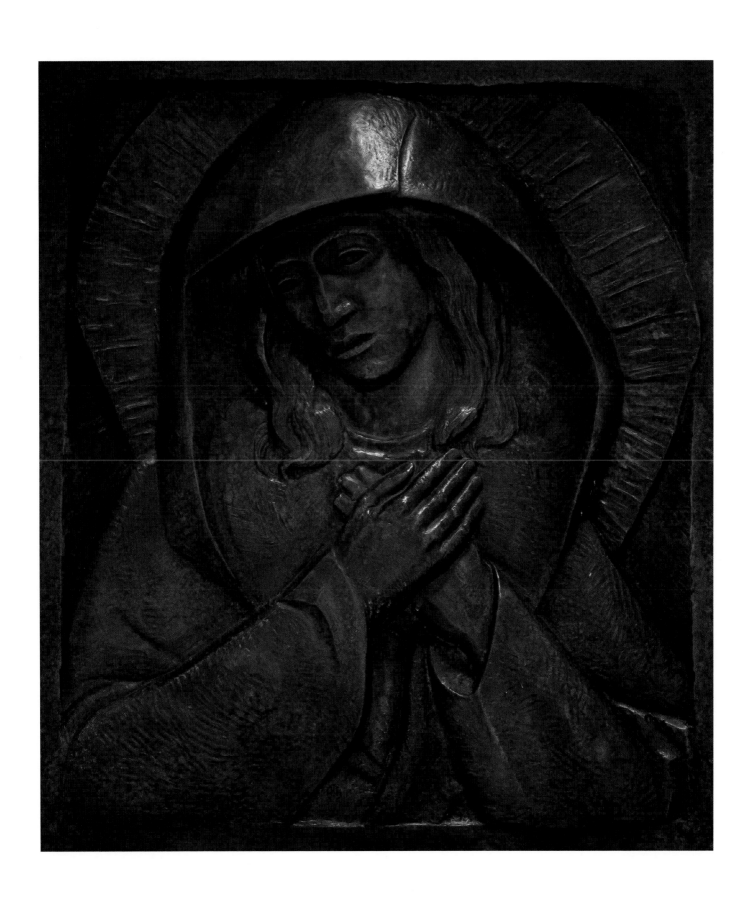

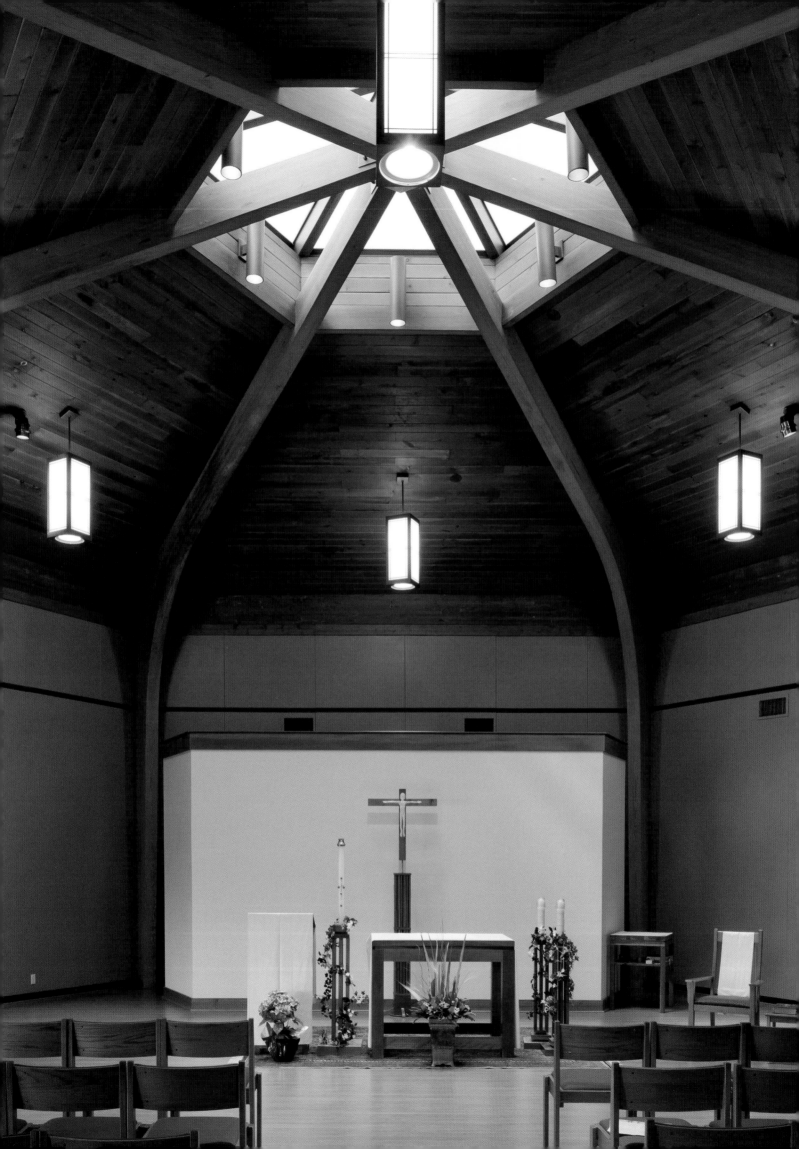

The Fatima Retreat Center has now been converted into a residence for priests of the Congregation of Holy Cross. The beautiful chapel, rather octagonal in shape, has a skylight that gives the chapel a sunlit quality. The altar, candelabra, ambo, and crucifix, each done in wood, are the work of Rev. James Flanigan, C.S.C. Toward the rear of the church, there is a tabernacle with the Blessed Sacrament reserved. Rows of seats, for the priests in residence, face the tabernacle. Those seats are in addition to the ones that face the main altar. The residence takes its name from Our Lady of Fatima, the famous Marian pilgrimage site in Portugal.

DATE BUILT:
1980

DEDICATION:
Our Lady of Fatima

ACCESS:
By appointment

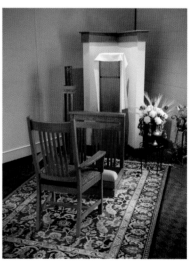

DATE BUILT:
1988

DEDICATION:
Our Lady – Seat of Wisdom

ACCESS:
By appointment

It is not uncommon for Father Hesburgh to scout up a student studying on the thirteenth floor to attend his daily Mass and do the readings of the day.

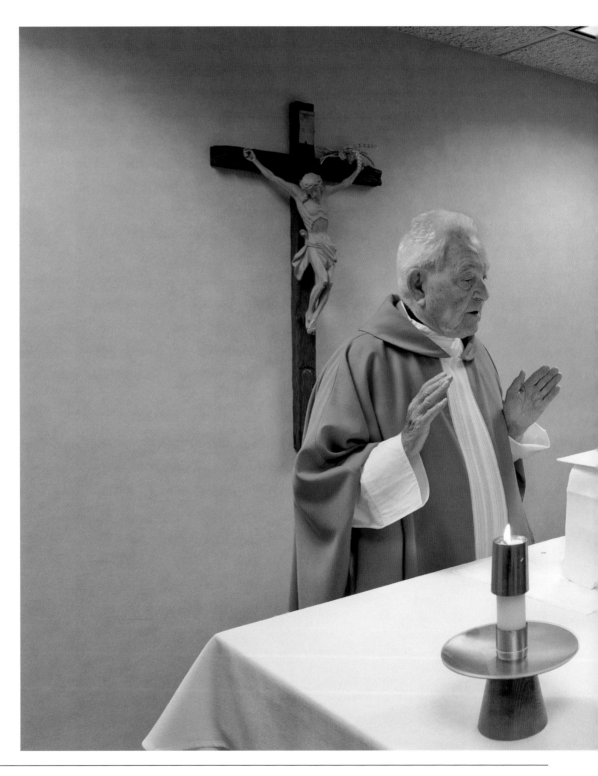

Adjacent to the office suite of Rev. Theodore Hesburgh, C.S.C., on the thirteenth floor of the library is an intimate chapel where Father Hesburgh celebrates Mass. Of special interest there is the framed drawing of the Pietà drafted by Ivan Meštrović as a study for the Pietà now in one of the apsidal chapels of the Basilica of the Sacred Heart on campus. It is signed and dated 1942. On the left wall is a wonderful leaded translucent framed figure inspired by the statue that is on top of the Golden Dome.

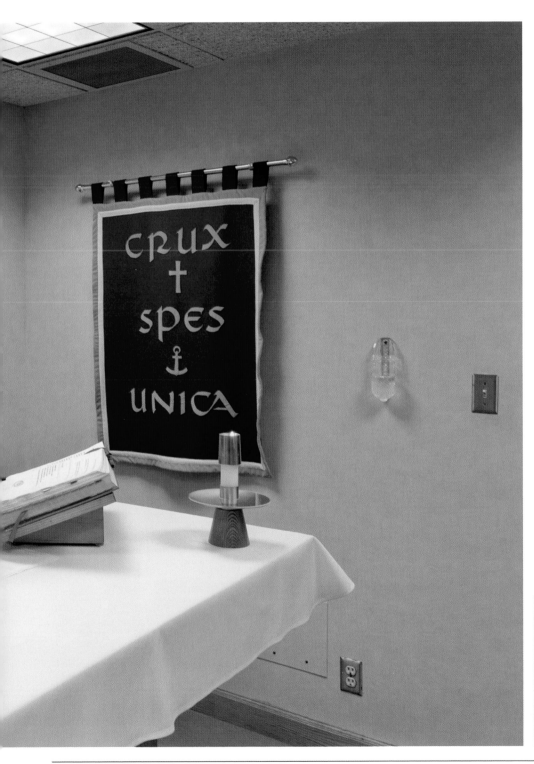

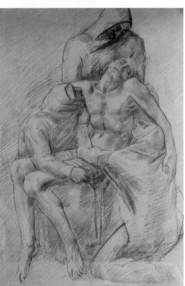

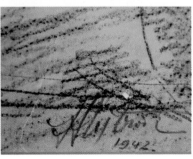

DATE BUILT:
1961

DEDICATION:
Saint Joseph

ACCESS:
By appointment

Now an assisted living facility for retired Holy Cross religious, Holy Cross House was renovated in 1999. The beautiful chapel is immediately to the right after one enters the facility. The rusticated stone walls are especially beautiful. Flanking the crucifix over the main altar are large liturgical banners. During Ordinary Time, the banner on the left has the chalice and host with grape decorations at the foot, while the banner on the right has wheat sheaves over which are the Greek letters Alpha and Omega. The first and last letters of the Greek alphabet are a symbol of Christ, derived from the twin use of the letters in the Book of Revelation: "I am the Alpha and the Omega, says the Lord God, who is and who was and who is to come, the Almighty" (1:8) and "I am the Alpha and the Omega, the first and the last, the beginning and the end" (22:13).

On the second floor there is a small adoration chapel with the Blessed Sacrament for the use of the residents.

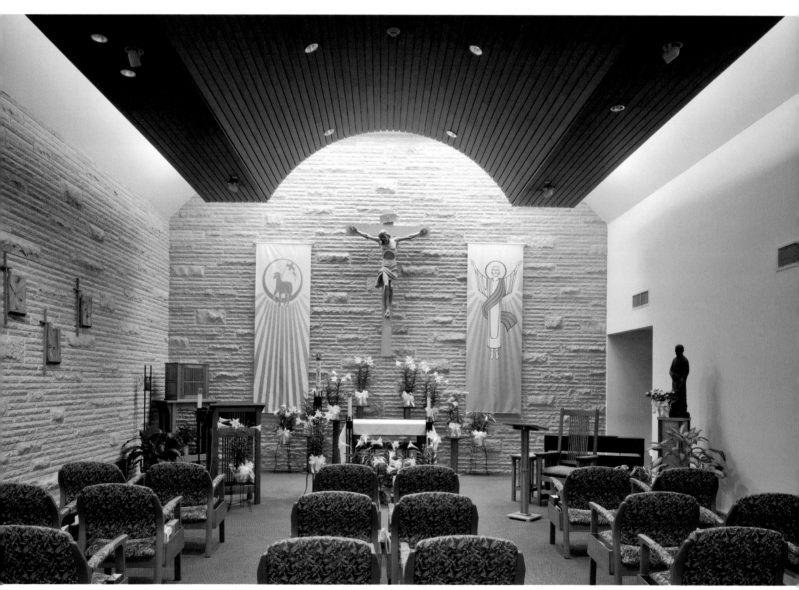

Chapel shown here decorated for Easter

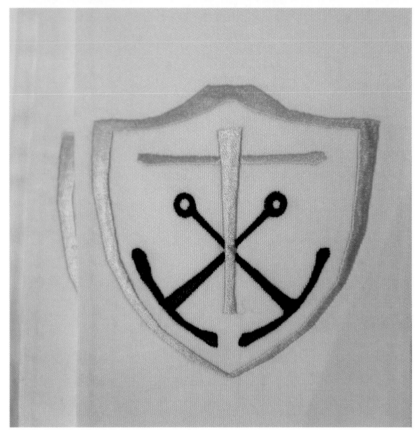

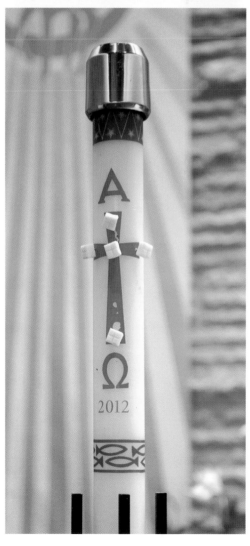

Apart from the historic nineteenth-century stained glass windows in the Basilica, this chapel has the most brilliant ensemble of glass on the campus. Designed by the late Rev. Anthony Lauck, C.S.C., the south wall behind the main altar depicts the holy angels who, as the liturgy assures us, worship God in the heavenly liturgy in communion with the Church on earth.

On the extreme left is the Angel of Judgment (I Thess 4:16) while on the right, holding a censer, is the Angel of the Apocalypse (Rev 8:3–4). In the center is the angel Michael flanked to the right by Gabriel and to the left by Raphael. The glass is "chunk" glass rather like the tesserae of a mosaic. The clerestory windows on the east and west sides of the chapel each have symbols of the Incarnation or the Passion of Christ. The seminary has graciously published a brochure of all the symbols in the glass for those interested.

Visitors to the chapel will note that in the back there is a semicircle of chairs facing away from the nave of the chapel. That area is used for morning and evening prayer by the seminary community.

The chapel is dedicated to the Sacred Heart of Jesus. The Church has long meditated on the cry of Jesus: "Let anyone who is thirsty come to me and let the one who believes in me, drink. As the Scripture says, 'Out of the believer's heart shall flow rivers of living water.'" (John 7:37–38).

In the corridor to the left of the main entrance to the chapel is a handsome statue of the Sacred Heart carved in wood.

DATE BUILT:
1960

DEDICATION:
Sacred Heart of Jesus

ACCESS:
By appointment

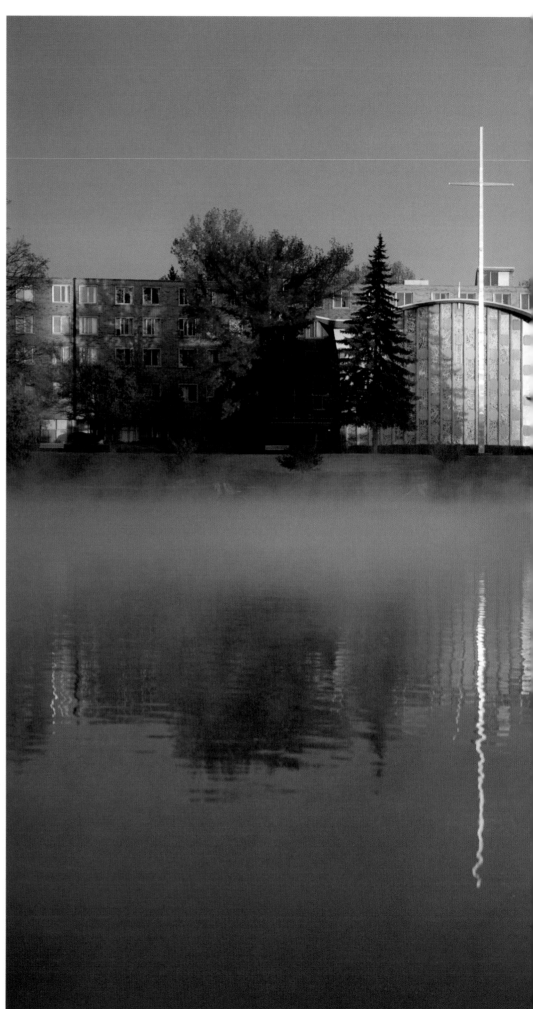

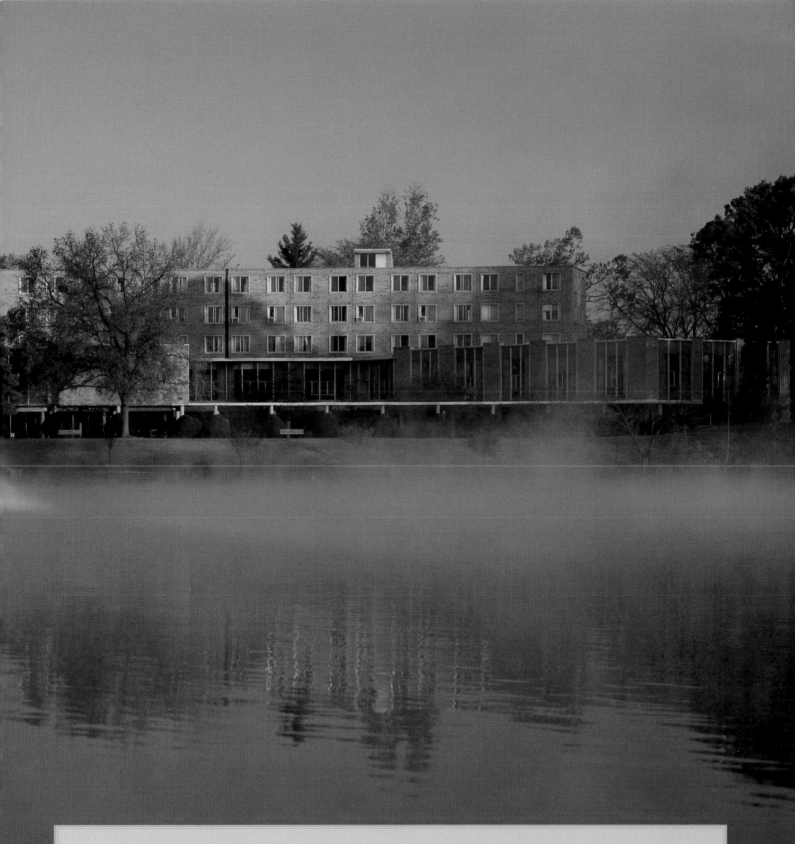

The Feast of the Most Sacred Heart of Jesus only became observed universally in the Catholic Church in 1856. It is celebrated on the Friday after the Feast of Corpus Christi. The Feast of the Most Sacred Heart of Jesus is the titular feast day of the priests of the Congregation of Holy Cross.

The University of Notre Dame is singular in that many of its academic

buildings contain chapels where the Blessed Sacrament reposes. The

Congregation of Holy Cross stands for the conviction that education is both

for the mind and for the heart. The presence of chapels in various buildings,

dedicated to one or other of the disciplines, is a concrete way

of demonstrating that dual aim of Catholic education. Mass is celebrated

daily in some of these halls during the academic term. It is not uncommon

to see students and staff stopping in these chapels for moments of

quiet meditation and prayer.

SAINT JOSEPH

DATE BUILT:
2012

DEDICATION:
Christ the Teacher

ACCESS:
During academic year

Carole Sandner Hall, dedicated in 2011, houses the Alliance for Catholic Education. The chapel (currently under construction) will hold approximately forty worshippers and will be under the patronage of Christ the Teacher. A crucifix framed by translucent alabaster will be behind the main altar, and immediately outside the chapel entrance will be a striking statue of Saint Anthony of Padua holding the Christ Child. He was named a Doctor of the Church by Pope Pius XII in 1946.

Artist's Rendering of Chapel

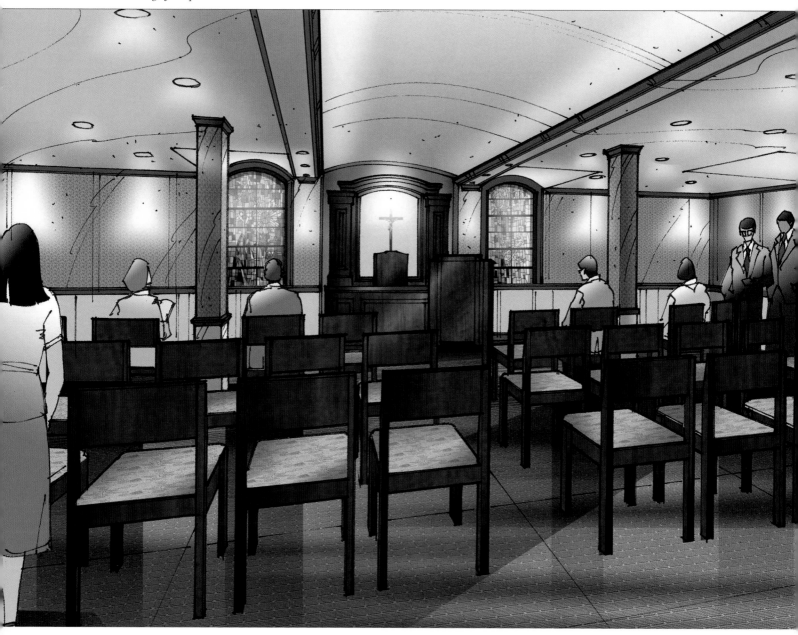

Photograph by Barbara Johnston

DATE BUILT:

2001

DEDICATION:

Notre Dame Our Mother

ACCESS:

During academic year

The windows of this chapel illustrate well the purpose of the Coleman-Morse Center, which is dedicated to academic services for students. The window labeled "Prayer" depicts Christ in Gethsemane; "Service" represents Jesus washing the feet of the disciples; "Study" shows Christ teaching; and "Recreation" illustrates Christ with children. On the wall opposite these windows is a modernistic mosaic of Notre Dame Our Mother, designed by a monk of Saint Meinrad Archabbey in Indiana. To the right of the altar is a tapestry of Saint John baptizing Jesus by the artist John Nava, who designed the tapestries for the Cathedral in Los Angeles. A somewhat abstract window with the symbol of the Eucharist is behind the altar. The back window of the chapel depicts the Holy Family, with Jesus and Saint Joseph to the left and Our Lady to the right.

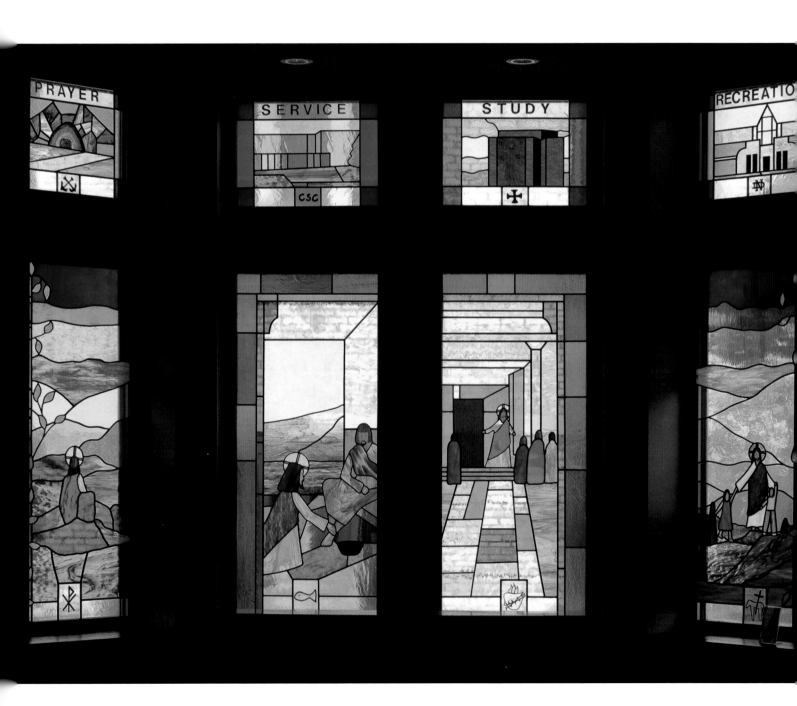

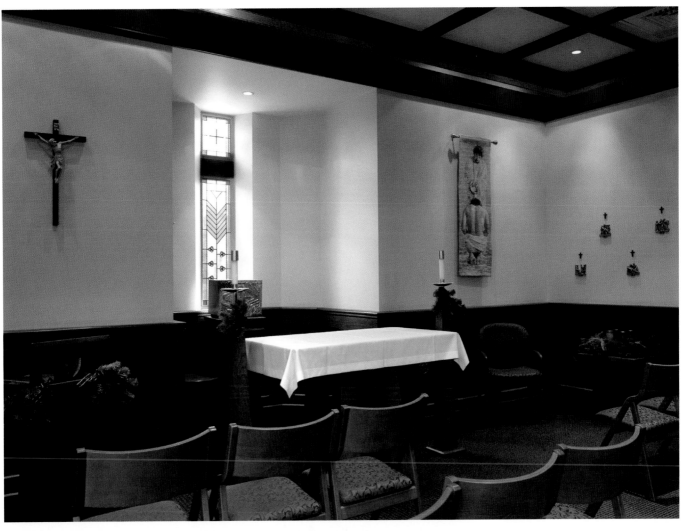

The Coleman-Morse Center, constructed on the site of the old
bookstore and dedicated in 2001, houses Campus Ministry, the
First Year of Studies Program, Academic Services for Athletes,
and, on the first floor, a capacious space for study, meetings,
and an attractive student lounge.

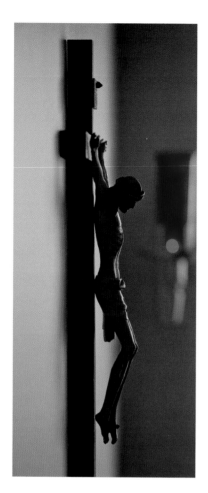

This chapel, located on the second floor, is one of the plainest of the campus chapels. The Blessed Sacrament is reserved in this chapel. During the school year, Mass is celebrated on the first Friday of each month. Originally Flanner was a residence hall, but it now houses various administrative offices, including the University of Notre Dame Press, Career Services, and much more. The director of Career Services reports that students will sometimes utter a quick prayer in the chapel before going in for a job interview.

DATE BUILT:
1969

DEDICATION:
Saint André Bessette

ACCESS:
During academic year

DATE BUILT:
2009

DEDICATION:
Our Lady of Mercy

ACCESS:
During academic year

This chapel was dedicated on October 1, 2009, under the patronage of Our Lady of Mercy, whose image, with an open cape embracing persons of every nation, is found behind the altar. The other stained glass windows illustrate the seven corporal works of mercy: Saints Vincent de Paul and Jane Frances de Chantal (feeding the hungry; giving drink to the thirsty); Martin of Tours (clothing the naked); Mother Teresa of Calcutta (welcoming the stranger); André Bessette (caring for the sick); Martin de Porres (visiting the prisoner); and The Myrrh-Bearing Women of the Gospel (burying the dead).

The tabernacle with its enameled Pietà and the crucifix with its inlaid tiles are done in the style of Latin American religious art, thus indicating the university's desire to be present in both Americas.

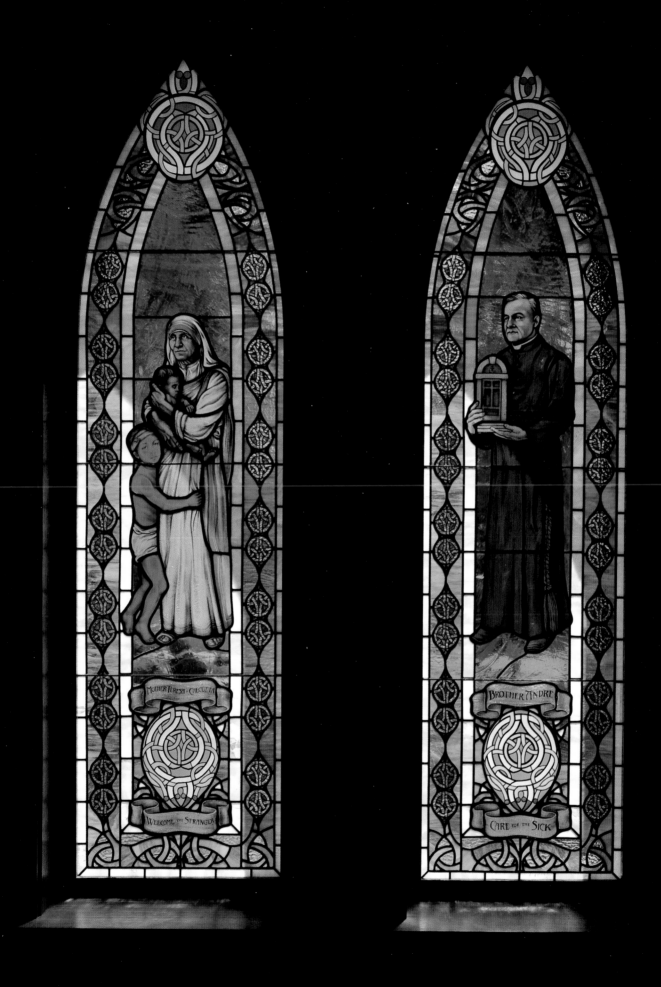

MOTHER TERESA CALCUTTA

BROTHER ANDRE

WELCOME THE STRANGER

CARE FOR THE SICK

The numbering of the traditional seven corporal works of mercy reflects the words of Jesus judging the world in Matthew 25:31–46.

The title of Our Lady of Mercy goes back to the early thirteenth century. Devotion to the Blessed Virgin, under that name, is especially popular in Central and Latin America.

DATE BUILT:
1988

DEDICATION:
Saint Thomas More

ACCESS:
During academic year

Saint Thomas More (1478–1535) is the patron saint of those who serve the law as lawyers and judges. Over the doorway leading into the chapel is a window with the coat of arms of the Congregation of Holy Cross. To the left of the main entrance is a window showing Saint Augustine of Hippo holding his crozier and an open book. The main stained glass window behind the altar shows the Blessed Sacrament exposed in a monstrance, with symbols of the Eucharist in the surrounding medallions: fishes and loaves; the lamb; grapes; wheat sheaves; the Chi Rho; and the pelican. In the right window is the figure of the Blessed Virgin with medallions of her symbols, including the crown, star, rose, lily, and pierced heart. To the left of the central window is the figure of Saint Thomas More, with surrounding symbols of the law and his life. These include at the upper left the Tower of London where he was executed.

Saint Thomas More's feast day is June 22nd.

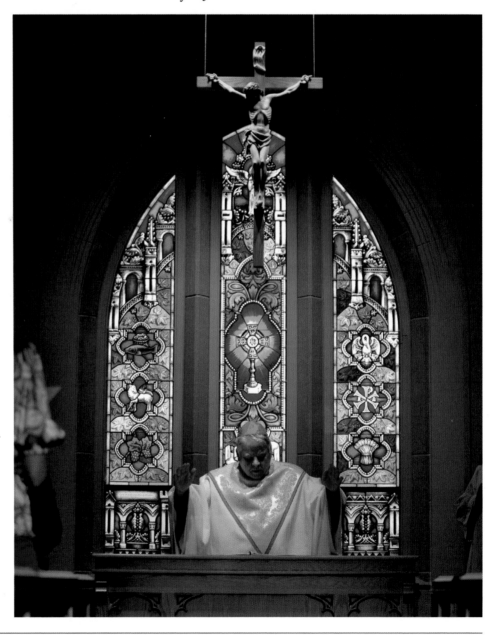

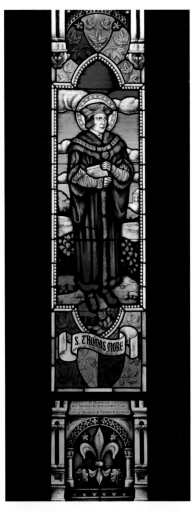

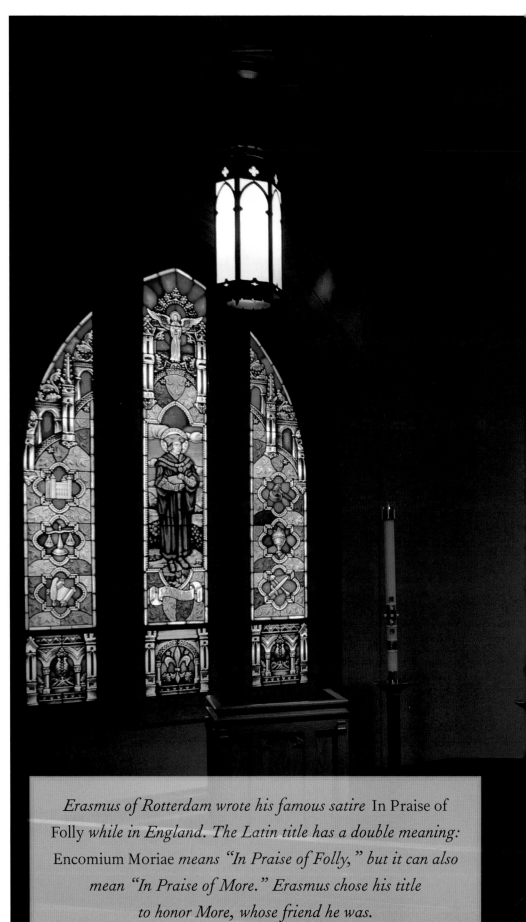

Erasmus of Rotterdam wrote his famous satire In Praise of Folly *while in England. The Latin title has a double meaning:* Encomium Moriae *means "In Praise of Folly," but it can also mean "In Praise of More." Erasmus chose his title to honor More, whose friend he was.*

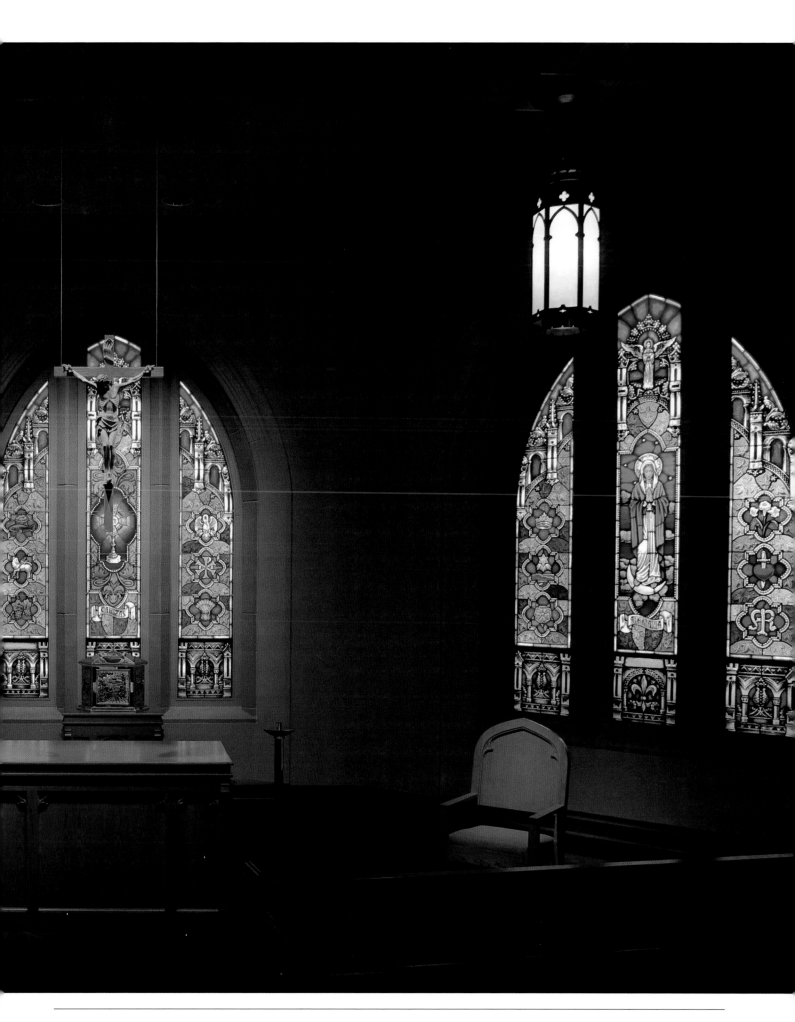

This tapestry of
Our Lady of Guadalupe
is dedicated to
Dean Patricia A. O'Hara
in recognition of her inspiring and visionary
leadership of the Notre Dame Law School from
1999 to 2009 and her unyielding devotion to
Our Lady's University,
on this the 24th day of April 2009,
by the Notre Dame Law
Association Board of Directors

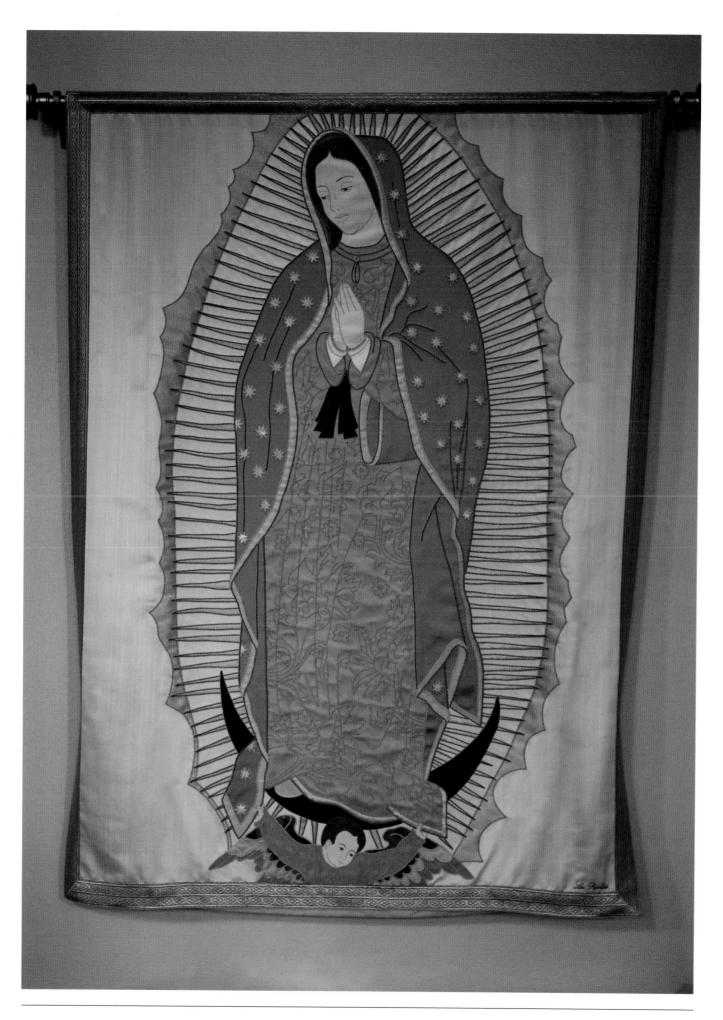

On the outside of Malloy Hall is a sculptured relief of Mary, Seat of Wisdom, set in a mandorla frame. Designed by Rev. James Flanigan, C.S.C., it adorns the exterior wall of the chapel. The chapel itself uses traditional tree motifs in the windows, which are symbols of wisdom. The various trees reflect a passage in the Book of Sirach (24:13–18) that is connected to the praise of wisdom. Catholic tradition has seen the figure of wisdom, praised in Sirach, as referring both to Christ and to Mary.

The crucifix over the main altar is a cast of an original made by Ivan Meštrović. The statue of Mary holding the Christ Child in the niche wall opposite the altar is a replica of a famous thirteenth-century French rendering of Madonna and Child.

The chapel's theme of wisdom is especially appropriate for a building that houses both the philosophy and the theology departments of the university. During the school year, Mass is celebrated daily in the chapel at the noon hour. Students in the Theology Department have regularly organized communal prayer during the week, especially in the Lenten season.

DATE BUILT:
2001

DEDICATION:
Mary, Seat of Wisdom

ACCESS:
During academic year

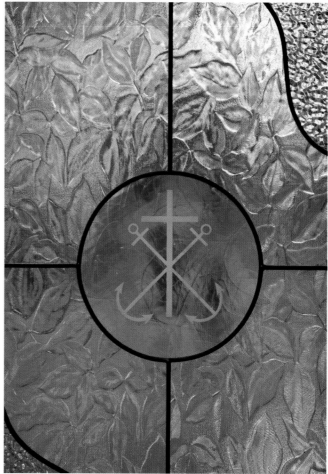

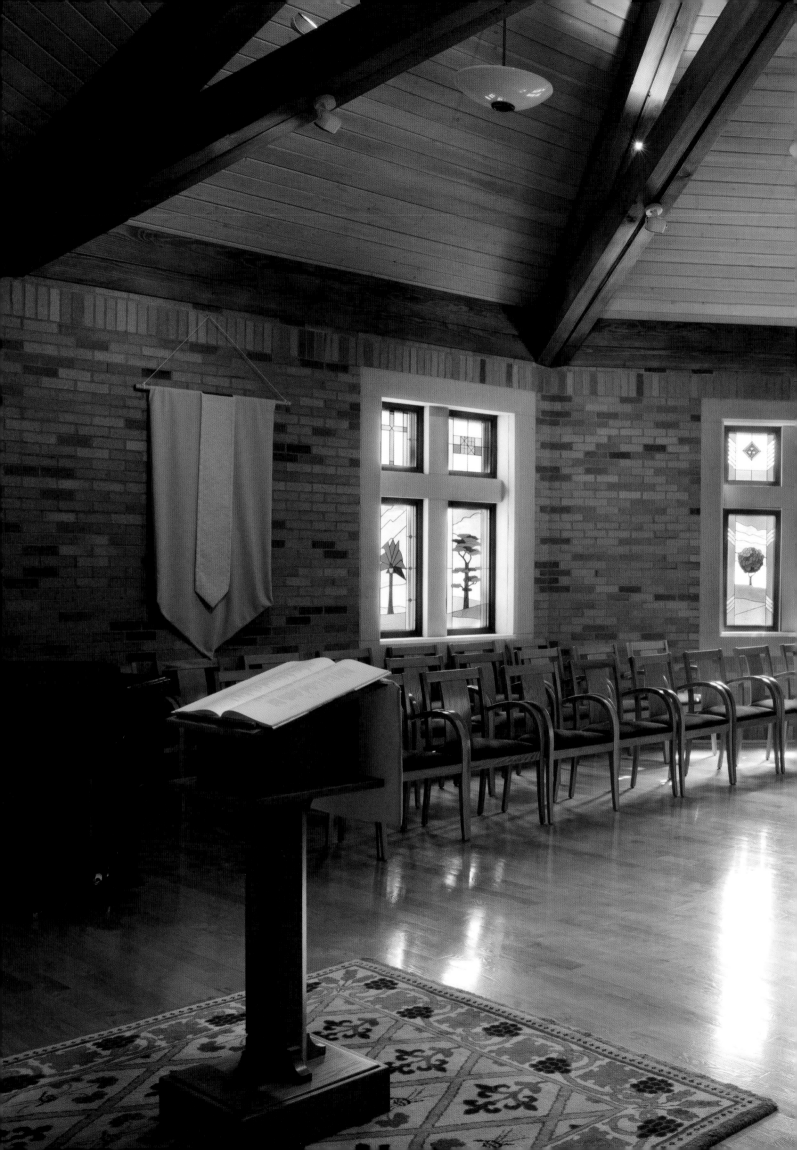

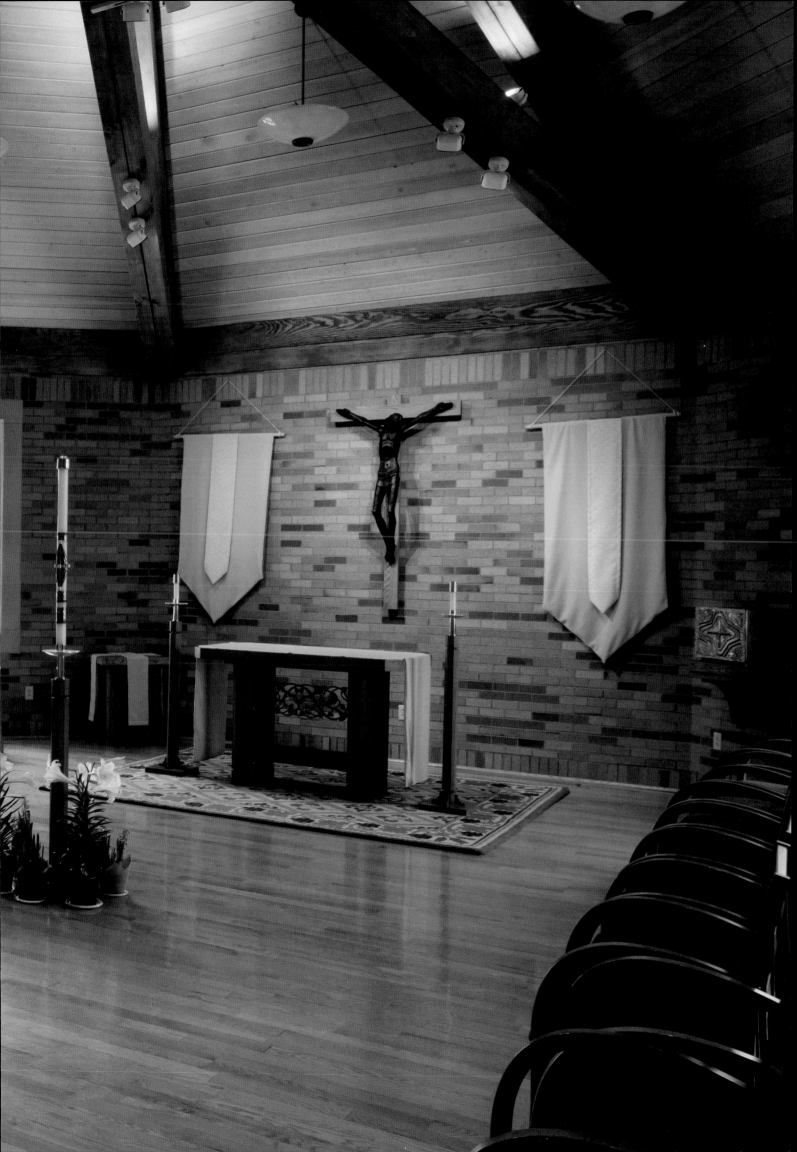

DATE BUILT:
1999

DEDICATION:
Our Lady of the Rosary

ACCESS:
During academic year

Located on the second floor of Mendoza, this snug chapel seats around twenty-five people, and weekday Mass is celebrated there every day of the school term. The windows mounted on the side walls have been recycled from the former minor seminary of the Congregation of Holy Cross. From the left facing the altar are the figures of Saint Patrick and Saint Joan of Arc(?). On the right, starting from the altar, are Saint Aloysius Gonzaga and an unknown saint.

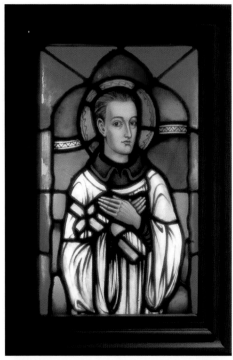

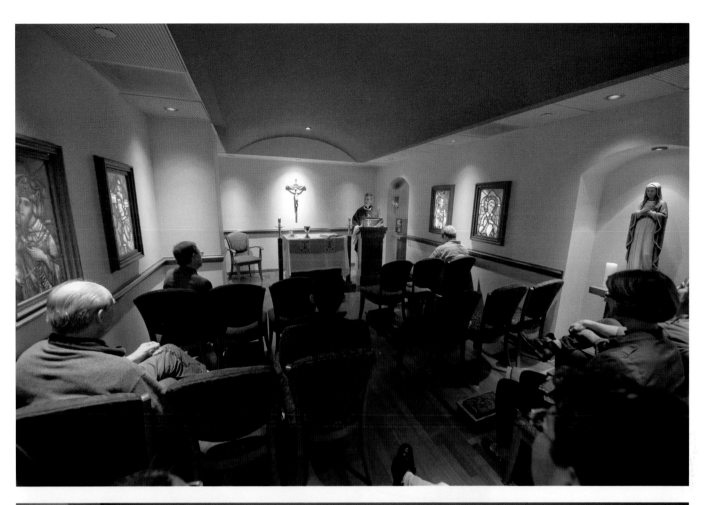

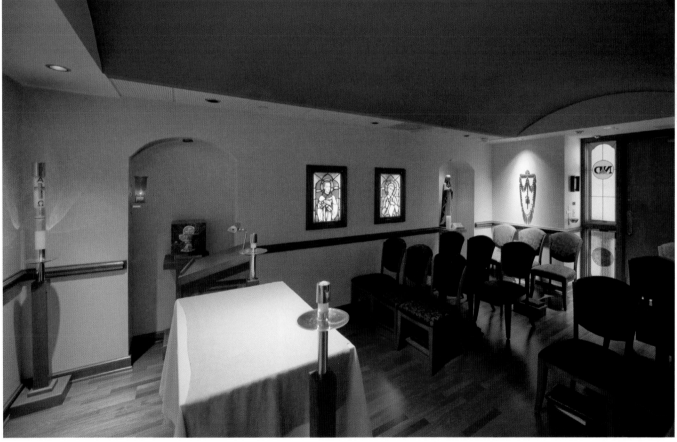

STUDENT HEALTH CENTER.

DATE BUILT:
1934

DEDICATION:
Saint William

ACCESS:
By appointment

Located on the second floor of the university infirmary, this small chapel (it seats about a dozen people) has the Blessed Sacrament reserved in it, but Mass is not celebrated there on a regular basis. Each morning, however, a Holy Cross priest brings Holy Communion to any student who is confined to the infirmary. Visitors to this chapel might find the wooden plaque of Saint Francis of Assisi on the back wall of interest.

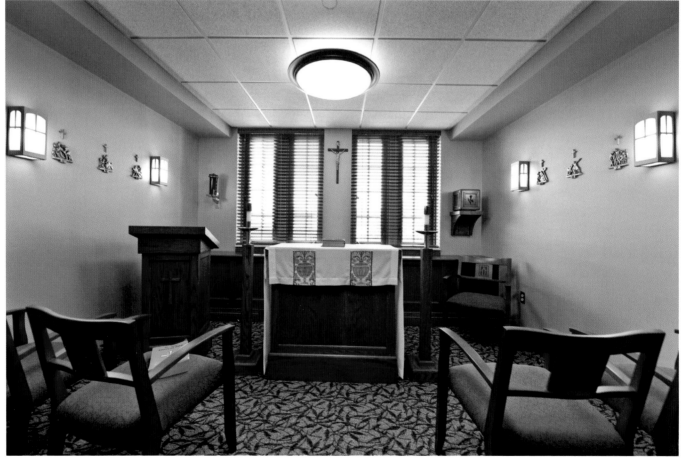

Liam is an abbreviated form of the name William. Both the
health center and the chapel are under the patronage of the
twelfth-century Saint William of York, whose shrine was famous
for healing miracles. The fifteenth-century "William Window"
in York Minster in England is the largest body of stained glass in
the British Isles, depicting, among other things, healing miracles
attributed to the saint.

The most recent addition to the university campus, this academic building devoted to executive education will be dedicated in 2012. The chapel will be dedicated to Saint Matthew the Apostle. The stained glass windows in the apse of the chapel will feature four saints: Stephen the Protomartyr, Cyrus (a fourth-century martyr), the apostle John, and Marguerite Bourgeoys.

DATE BUILT:
2012

DEDICATION:
Saint Matthew the Apostle

ACCESS:
During academic year

Saint Marguerite Bourgeoys (1620–1700), the foundress of the Sisters of Notre Dame of Montreal, was canonized by Pope John Paul II in 1982. She is Canada's first female canonized saint.

Artist's Rendering of Chapel

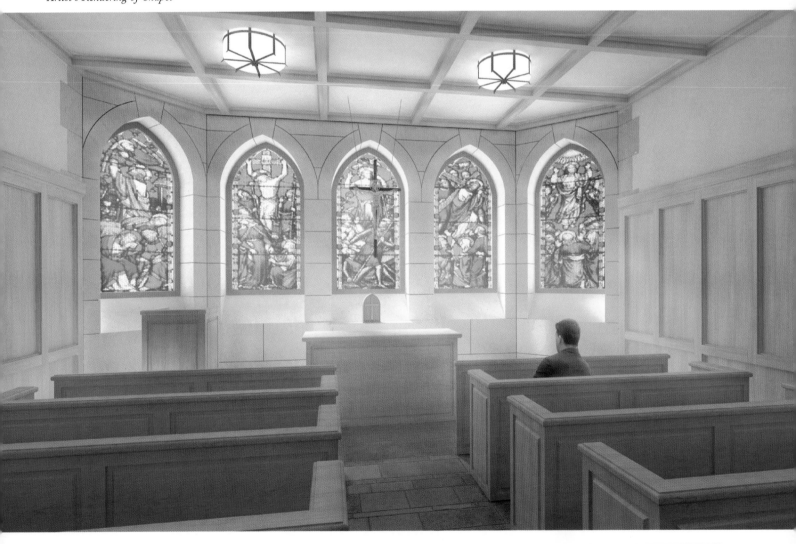

The chapel in the new Engineering Building is striking for its stained glass windows with their allusions to the Congregation of Holy Cross. The windows, replete with images of flora and fauna, represent the four seasons of the year. The Saint Joseph window (Spring) honors the patron saint of the Holy Cross brothers and of engineers. The window has flanking lancets with symbols of the saint. Our Lady of Sorrows (Summer) is the patroness of the Congregation of Holy Cross. Her seven-starred halo represents her seven sorrows. Sharp-eyed viewers will spot a little mouse peeking out from a rose. Blessed Basil Moreau (Autumn) has a pumpkin patch at his feet and a wedge of flying geese over his head. Saint André Bessette (Winter) stands amid falling snowflakes. The side medallions recall his life at Notre Dame College and the Oratory of Saint Joseph in Montreal.

DATE BUILT:
2010

DEDICATION:
Holy Cross

ACCESS:
During academic year

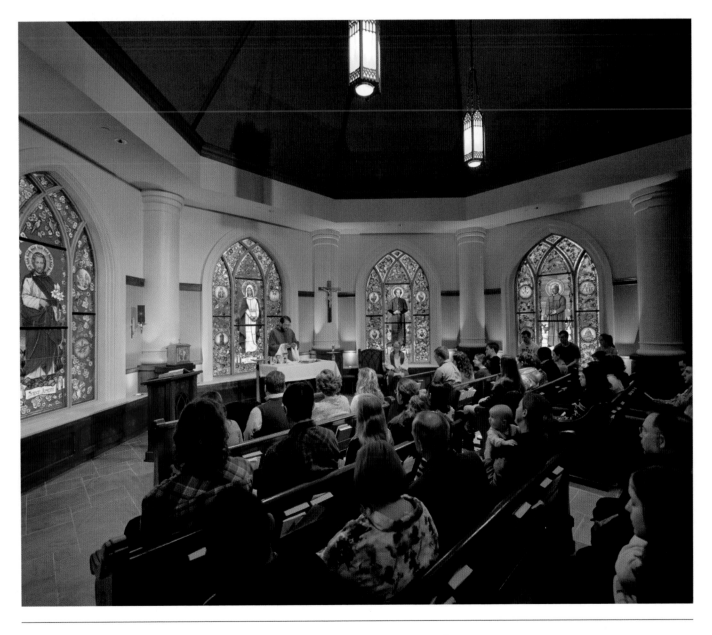

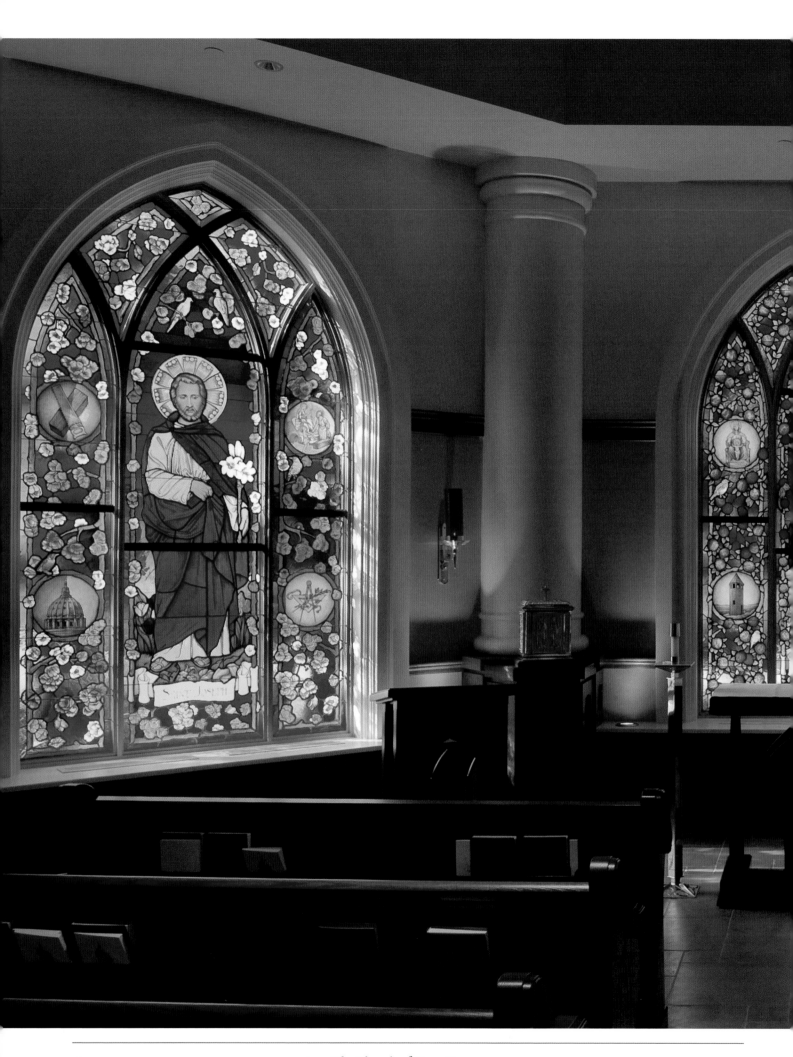

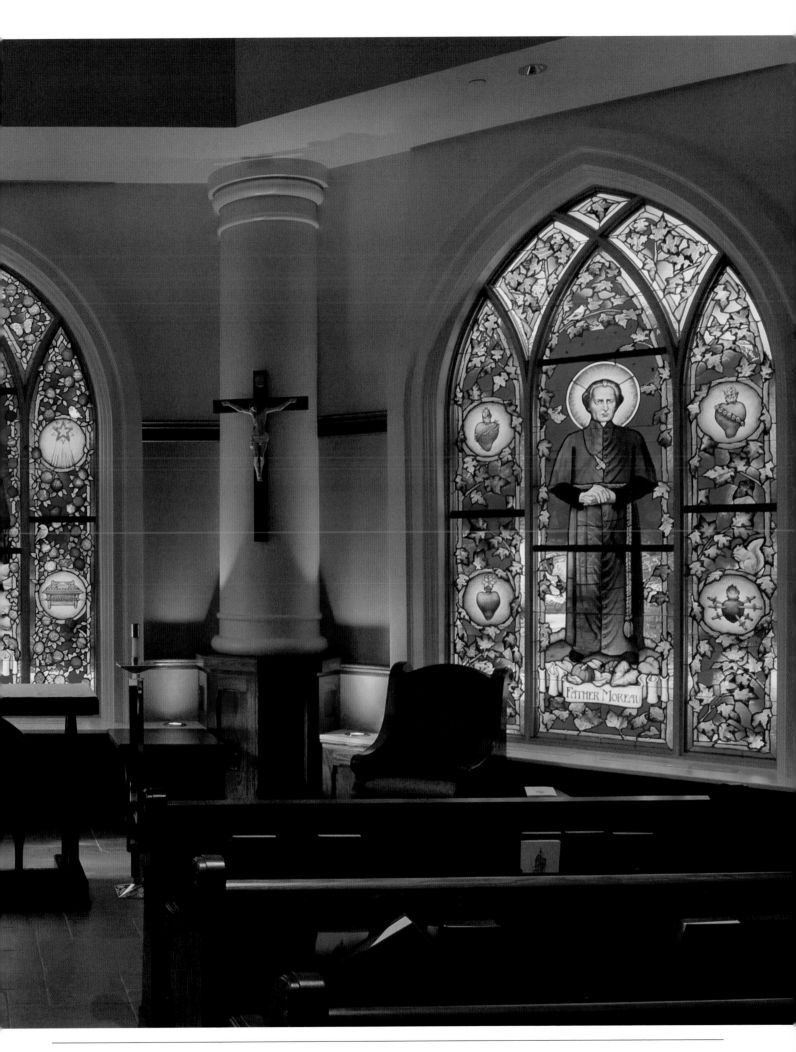

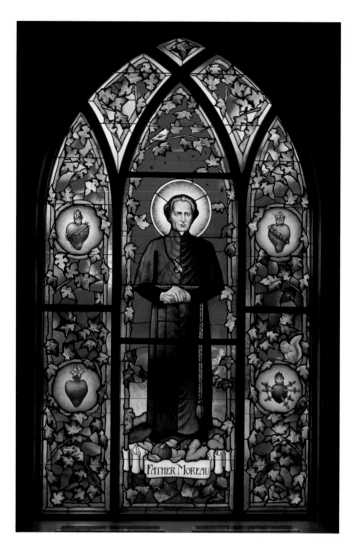

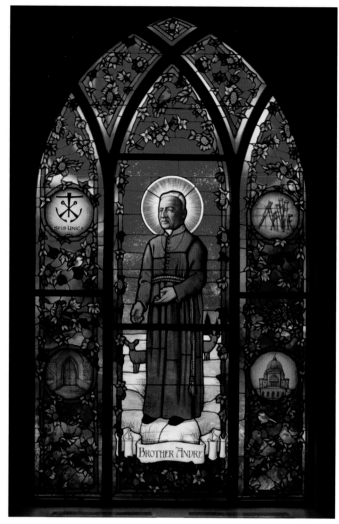

The Feast of Our Lady of Sorrows
is celebrated on September 15th.
The seven sorrows are: the
prophecy of Simeon about the
sword which will pierce her heart;
the flight into Egypt; the loss
of the child Jesus in Jerusalem;
the meeting of Mary and Jesus
on the way to Calvary; Mary
standing at the foot of the cross;
the taking down of the body of
Jesus from the cross; laying
Jesus in the tomb.

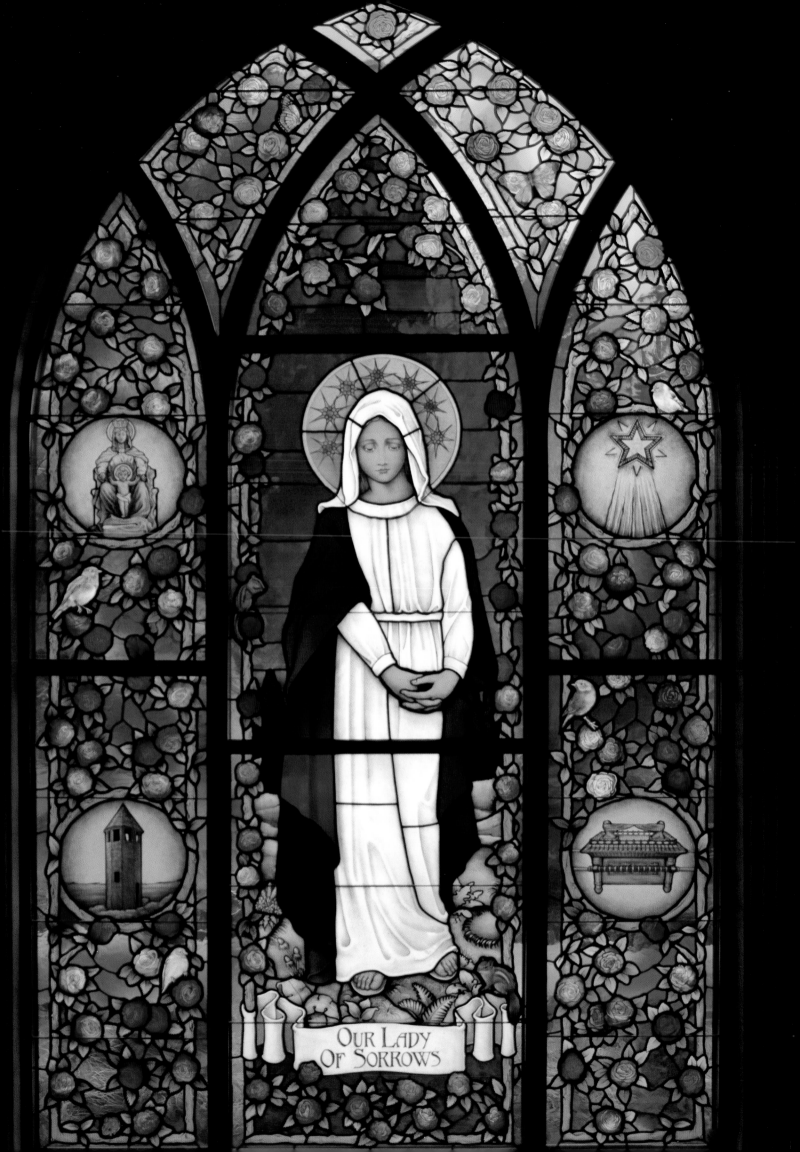

OUR LADY
OF SORROWS

As the custom of priests celebrating individual Masses grew in the Latin West in the early Middle Ages, chapels either along the side aisles or radiating out from the walking space (called the ambulatory) around and behind the main altar of large churches became increasingly common in both Romanesque and Gothic buildings. These side altars were also utilized for devotional purposes or as repositories for the Blessed Sacrament or sacred relics. They were often dedicated to a particular saint, and there was usually a Marian chapel for devotion to the Blessed Virgin.

A visitor to the Basilica of the Sacred Heart can easily view seven chapels. Six of these chapels are located on either side of the main altar, and a seventh is located behind the main altar at the end of the apse. A final chapel (the so-called Bishop's Chapel) is not available to the public. The crypt church below the Basilica is technically not a chapel. It serves as the parish church of Sacred Heart.

THE APSIDAL CHAPELS

BASILICA OF THE SACRED HEART

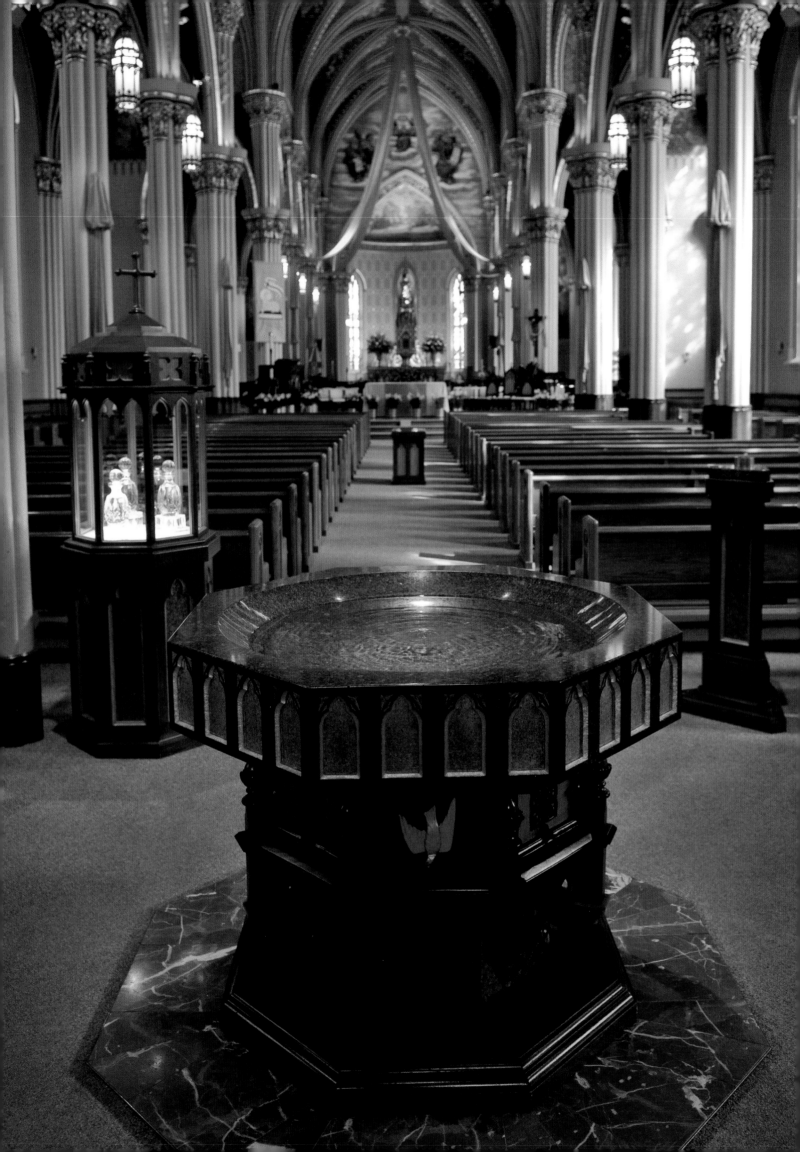

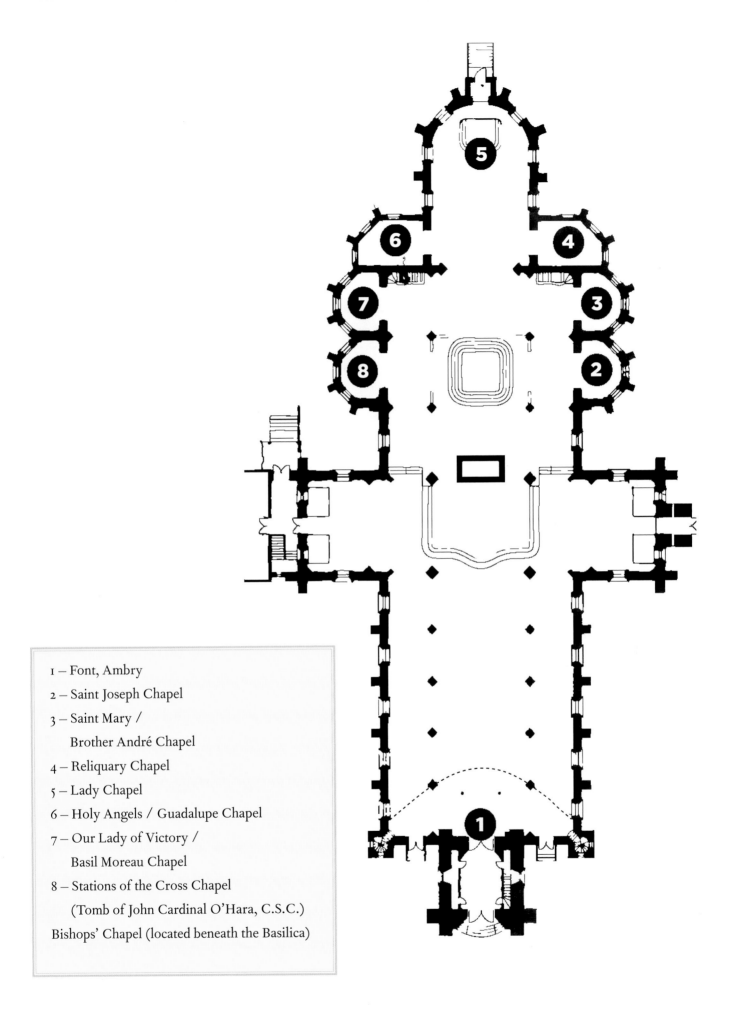

1 – Font, Ambry

2 – Saint Joseph Chapel

3 – Saint Mary /
 Brother André Chapel

4 – Reliquary Chapel

5 – Lady Chapel

6 – Holy Angels / Guadalupe Chapel

7 – Our Lady of Victory /
 Basil Moreau Chapel

8 – Stations of the Cross Chapel
 (Tomb of John Cardinal O'Hara, C.S.C.)

Bishops' Chapel (located beneath the Basilica)

DATE BUILT:
1900

DEDICATION:
Saint Joseph

ACCESS:
During Basilica hours

Dedicated to the patron saint of the Holy Cross brothers, this chapel now houses the monumental Pietà that Ivan Meštrović began to carve in 1942 in Rome from a single piece of Carrara marble. Brought to the United States and exhibited at the Metropolitan Museum of Art in New York City, it was then given on permanent loan to Notre Dame by the sculptor. Clearly, the Meštrović Pietà found its inspiration from the unfinished Pietà (now in the cathedral in Florence) that Michelangelo wanted to be his burial monument.

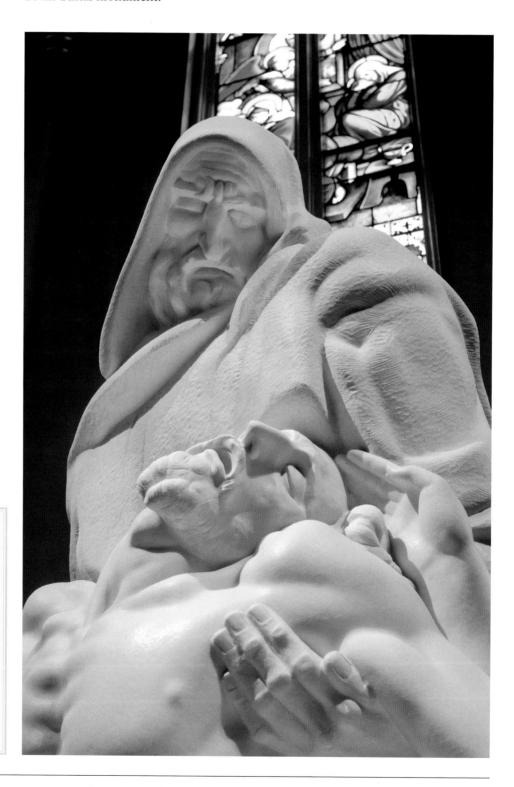

The face of Joseph of Arimathea is a self-portrait of the sculptor; the Virgin is inspired by the artist's wife; and Mary Magdalene is modeled on the artist's daughter.

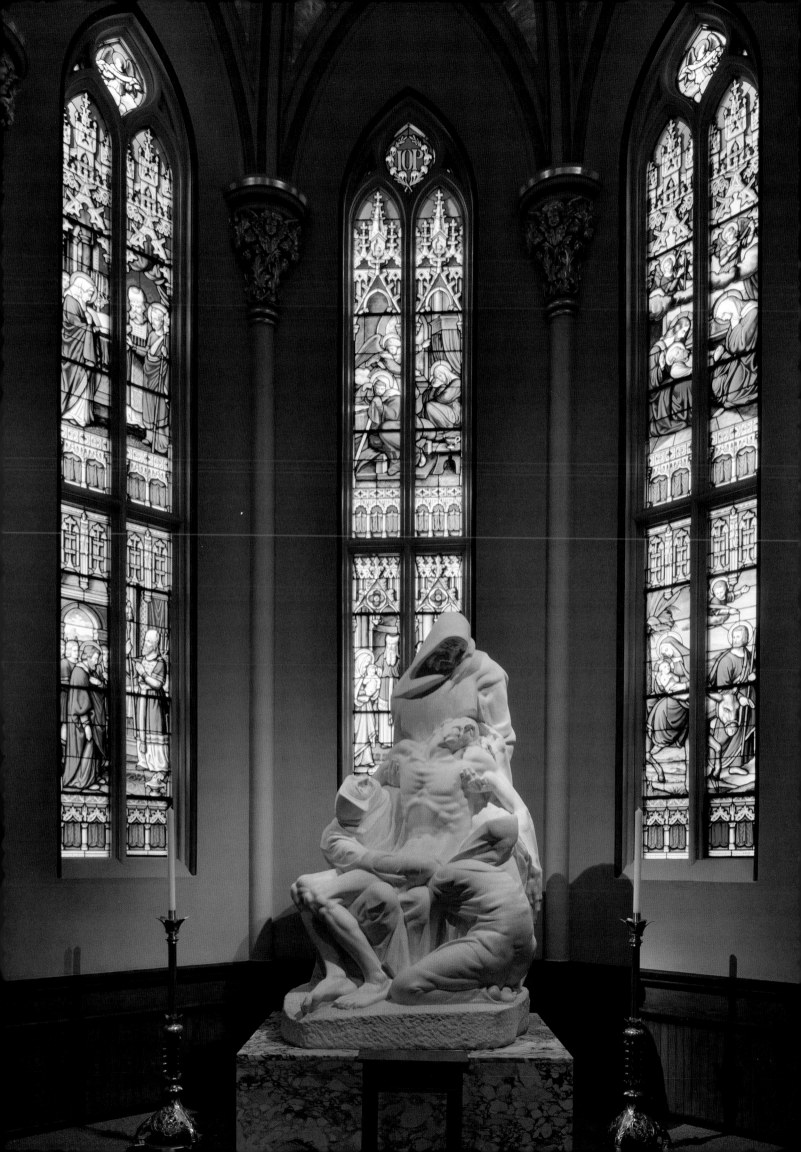

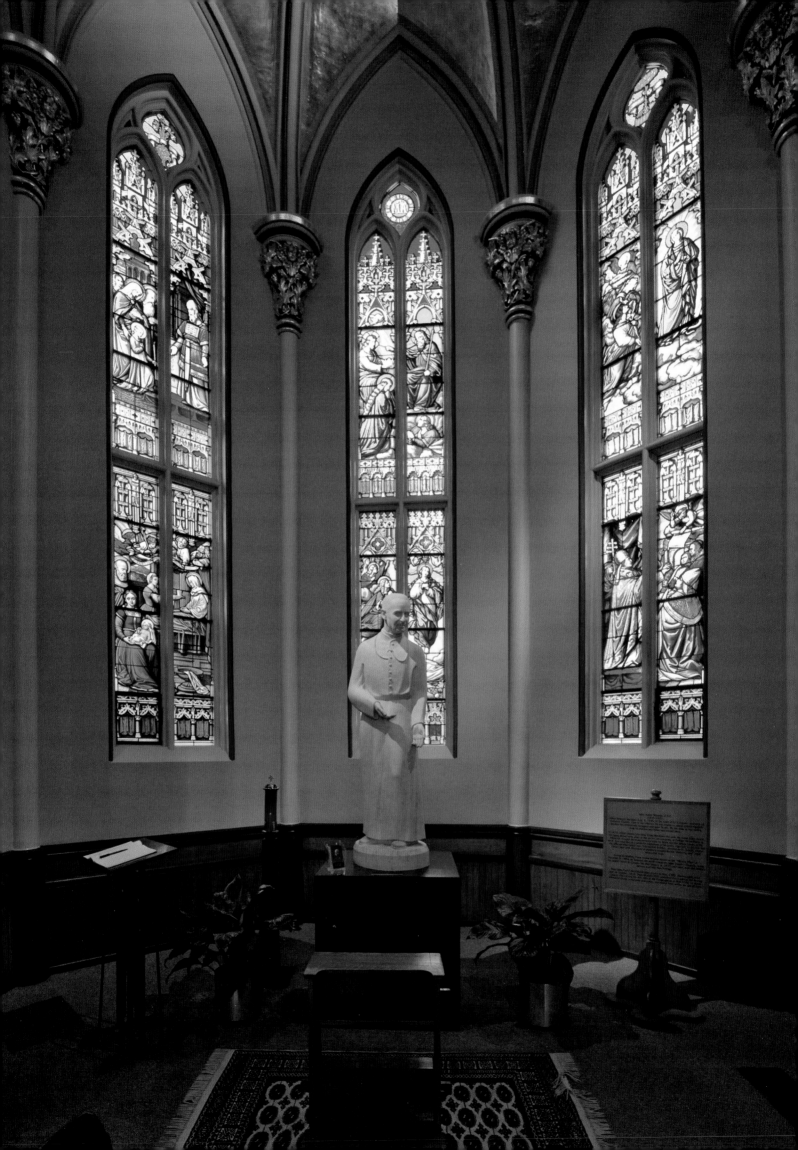

This chapel has a statue of Saint André Bessette, C.S.C., the first canonized saint of the Congregation of Holy Cross. The statue was carved, blessed, and installed in 1985 by the late Rev. Anthony Lauck, C.S.C. Brother André was beatified by Pope John Paul II in 1982 and canonized by Pope Benedict XVI in 2010. His feast day is celebrated on January 6th. Off to the side is a book for visitors to leave prayer petitions to invoke the intercession of the saint.

DATE BUILT:
1900

DEDICATION:
Saint Mary

ACCESS:
During Basilica hours

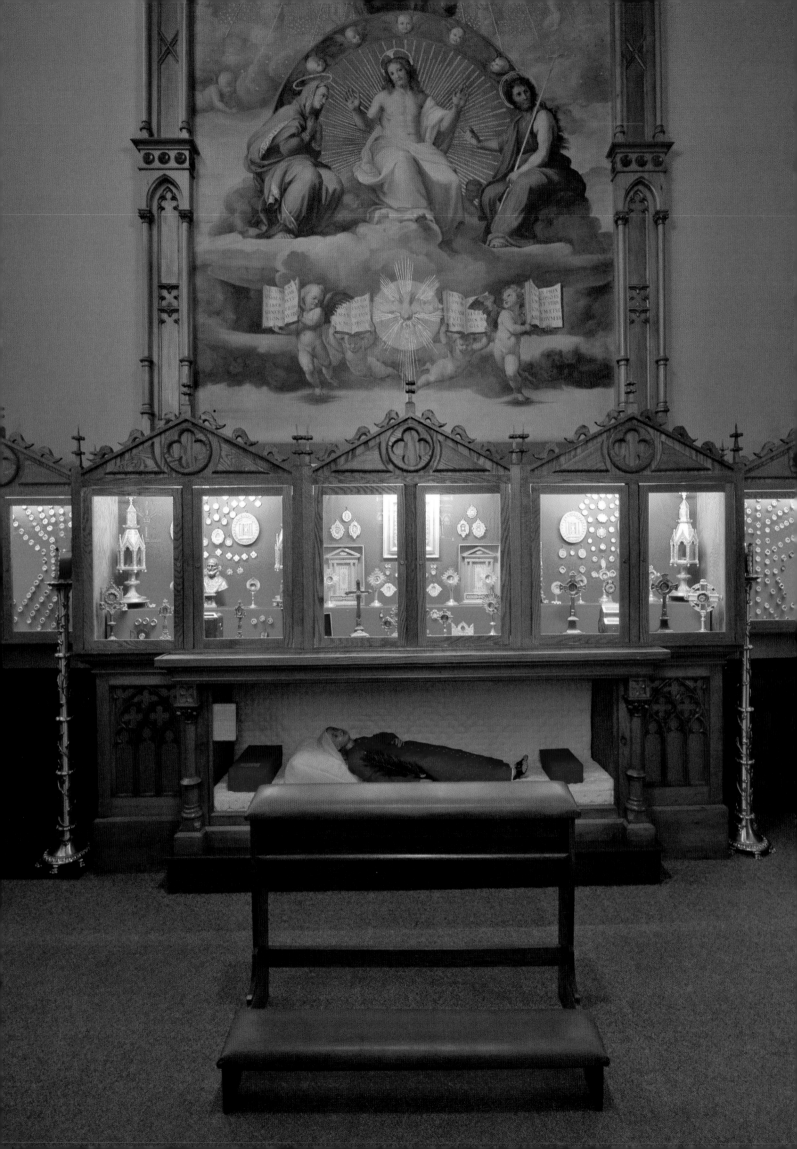

This chapel contains a large collection of relics assembled from the days of Father Sorin. A large glass-fronted reliquary housing numerous relics stands over an effigy of the third-century martyr Saint Severa; at her head and feet are lead containers containing fragments of her bones. The large wooden cross on the wall to the right of the reliquary has a relic of the True Cross embedded within it. This cross is often used in liturgical celebrations and carried at the head of the Stations of the Cross procession on the Fridays of Lent. On the wall opposite the reliquary is an exact copy of the icon of Our Lady of Czestochowa that resides at the Jasna Góra ("Shining Mountain") monastery in Poland.

DATE BUILT:

1900

ACCESS:

During Basilica hours

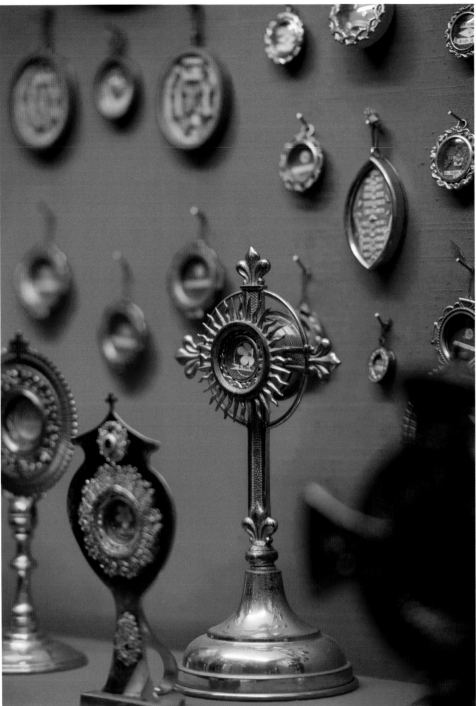

The word "chapel" derives from the Latin cappa, *meaning a cloak. The word "cappa" first referred to the cloak of Saint Martin, which was carried before the Frankish kings, and then, by extension, to the container for that cloak. Eventually it became the word "cappela" for a particular sacred object and then for the place that housed it. The priest attending the relic was a "cappelanus," from which we get the word "chaplain."*

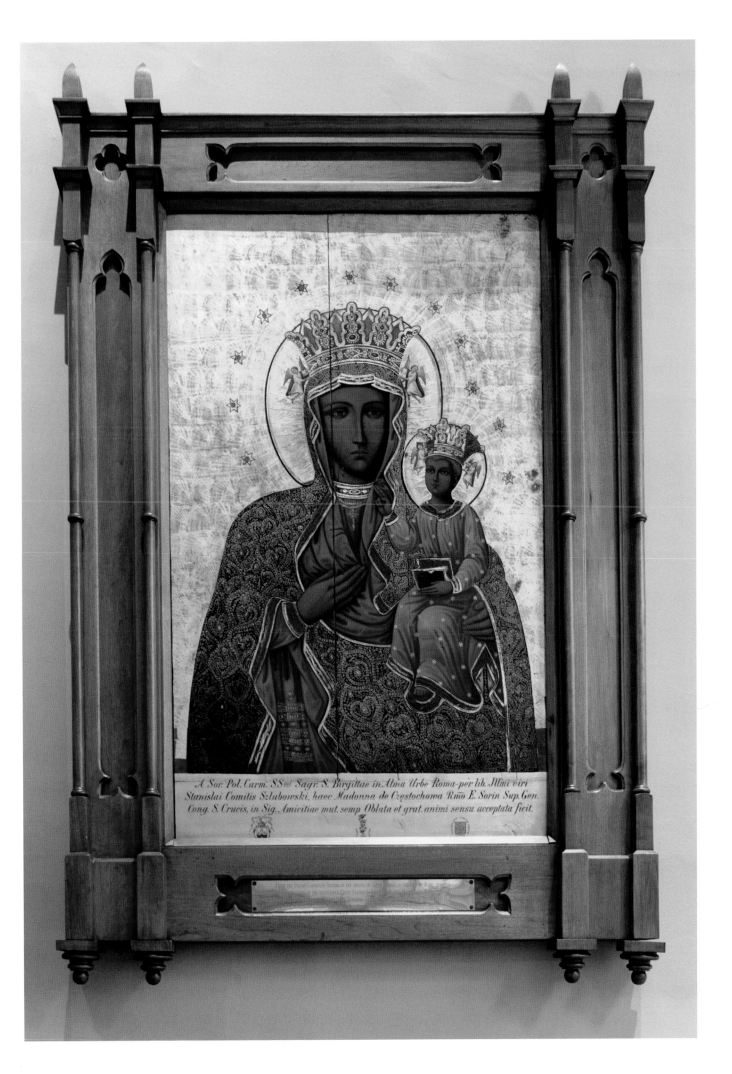

DATE BUILT:
1886

DEDICATION:
Exaltation of the Holy Cross

ACCESS:
During Basilica hours

This chapel, at the far end of the apse, is also known as the Chapel of the Exaltation of the Holy Cross (so named for the fresco in the ceiling above on that theme, with the words of the motto of the Congregation of Holy Cross emblazoned below the cross: *Spes Unica*—Our Only Hope).

In a niche above the chapel is a statue of Our Lady holding the Christ Child, done in a manner reminiscent of such depictions found in the Cathedral of Chartres.

The baroque altar, bordering on the rococo in style, comes from the Roman workshop of Bernini. It dates from the late seventeenth or early eighteenth century. The body of Christ on the altar's cross is carved from olive wood harvested in the Holy Land.

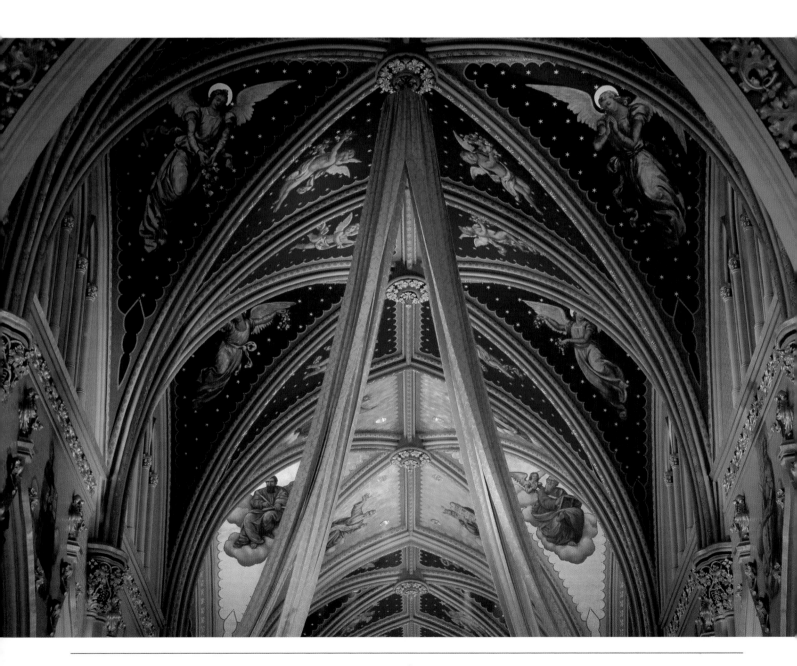

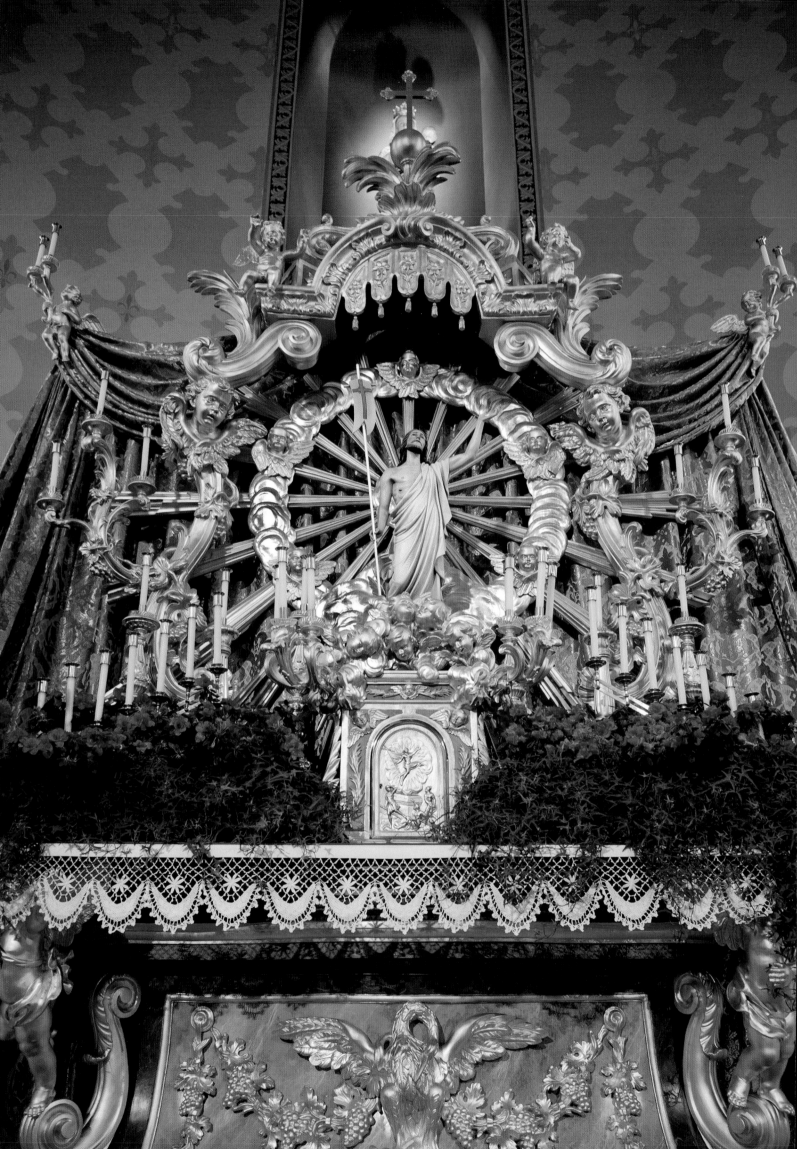

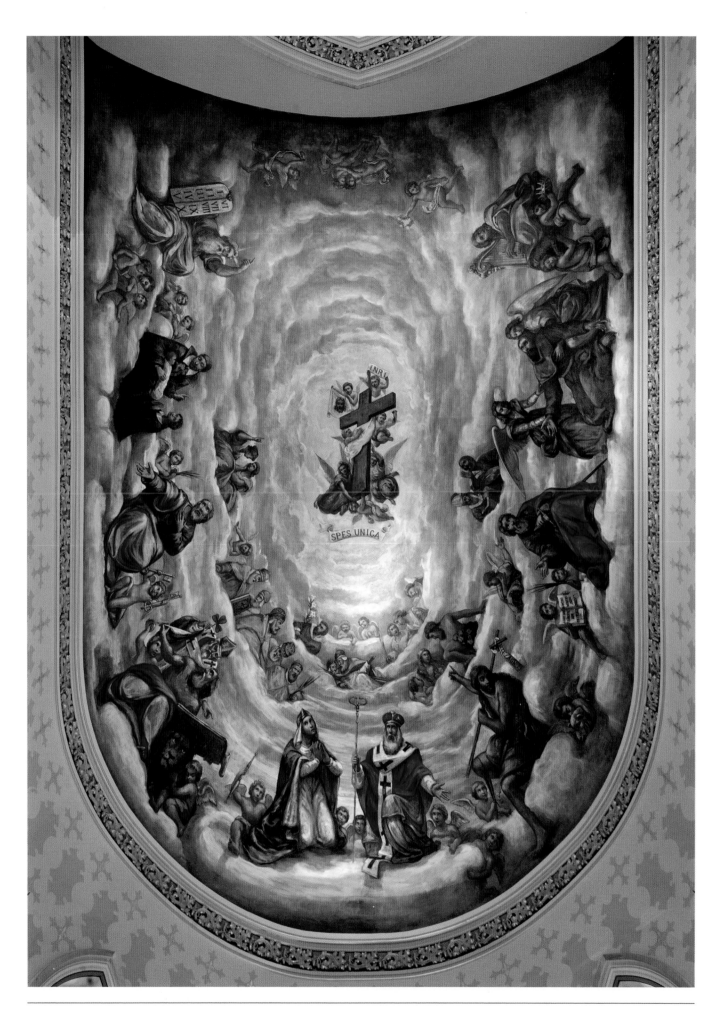

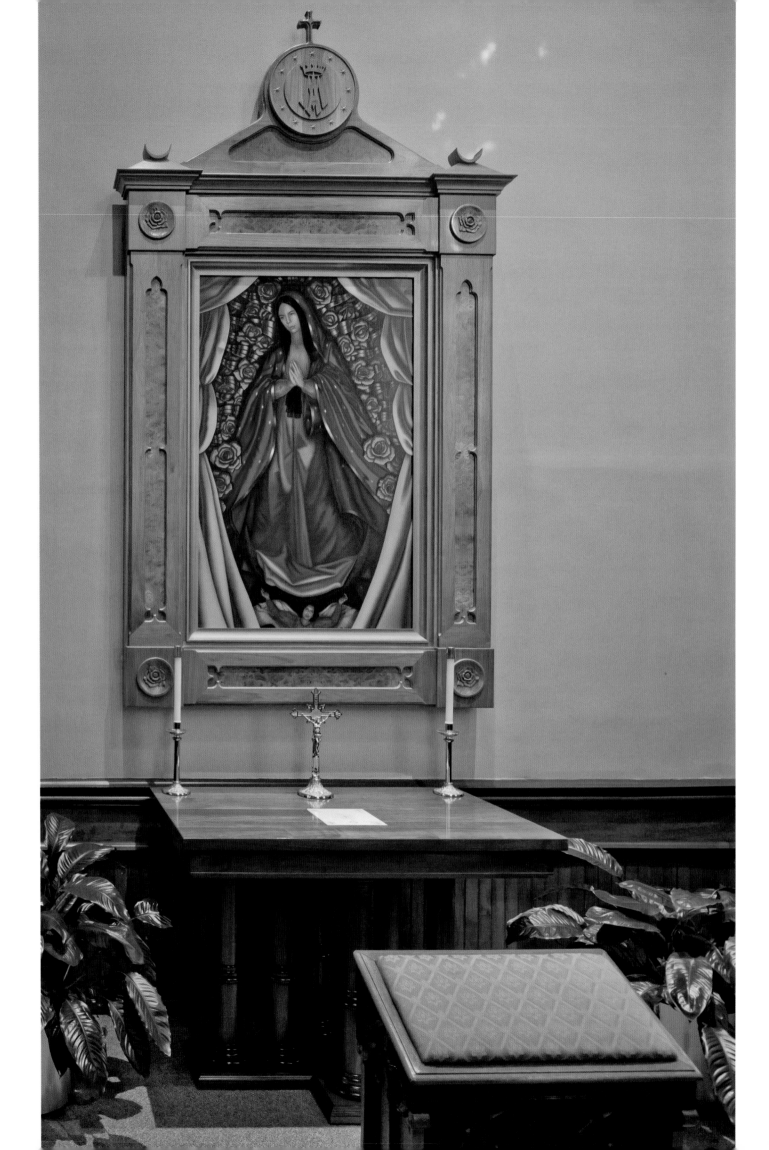

This chapel, on the west side of the Basilica, once honored the recipients of the Laetare Medal, which the university awards, as it has done since 1883, to an outstanding American Catholic. The Laetare memorabilia are now housed on the ground floor of the main building.

In 2008 a large painting of Our Lady of Guadalupe was installed in this chapel. Painted by Maria Tomasula, artist and professor of art at the university, the work was installed on December 12th, the feast day of Our Lady of Guadalupe.

On the wall opposite is a print of the Holy Face, which once was located in the chapel of Old College.

DATE BUILT:
1900

DEDICATION:
Holy Angels

ACCESS:
During Basilica hours

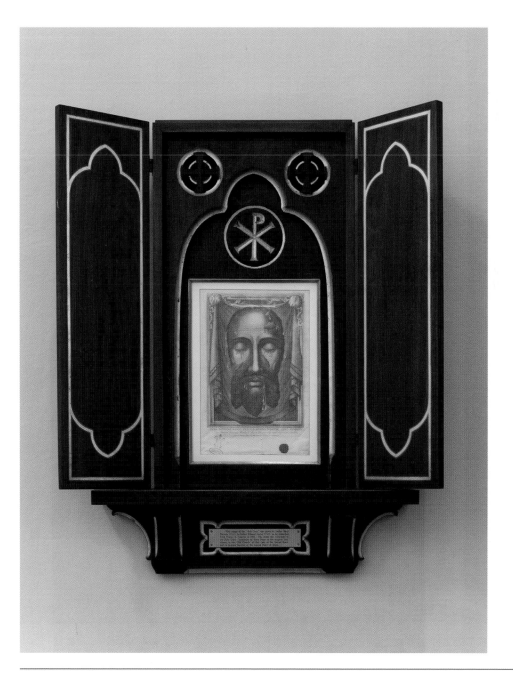

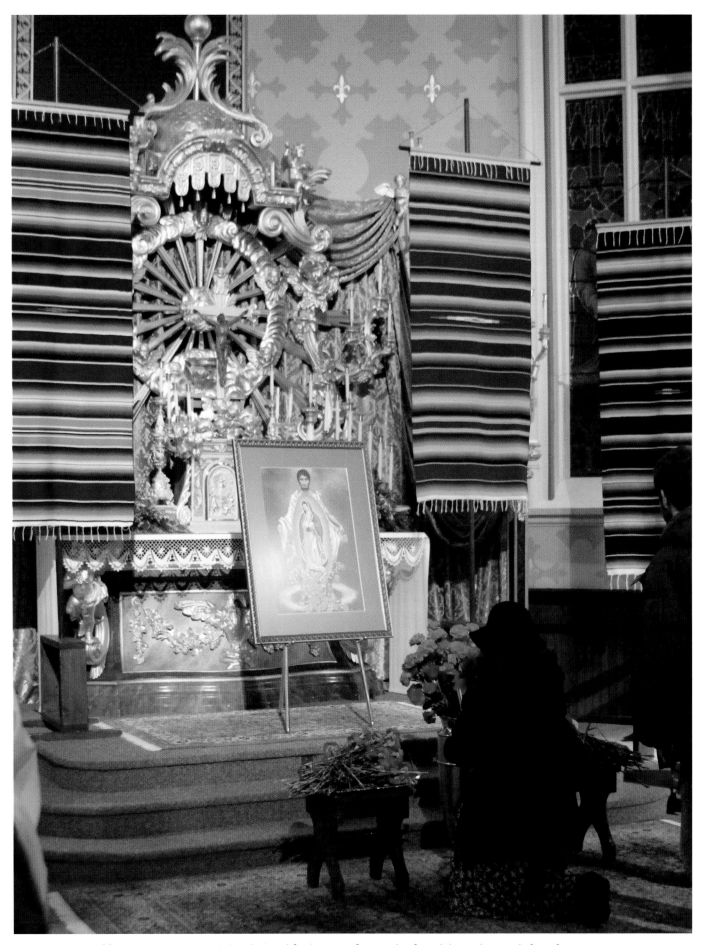

Above and bottom of facing page: Lady Chapel altar decorated for the Feast of Our Lady of Guadalupe. Photographs by Robert M. Dunn.

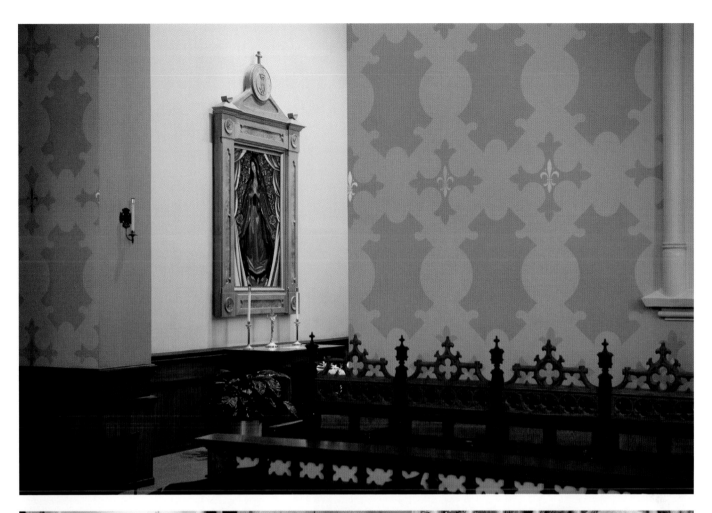

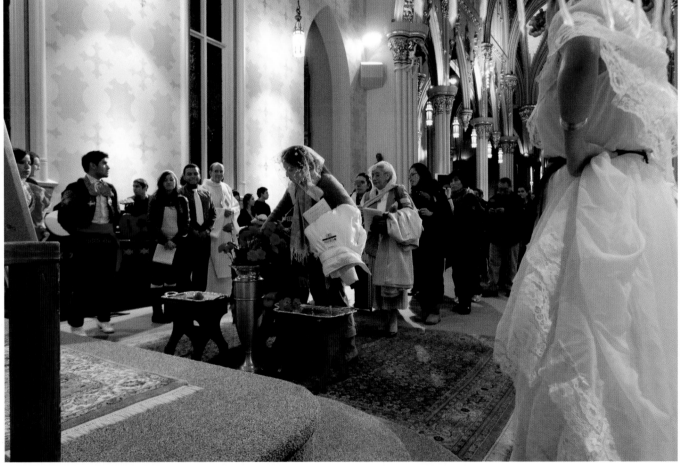

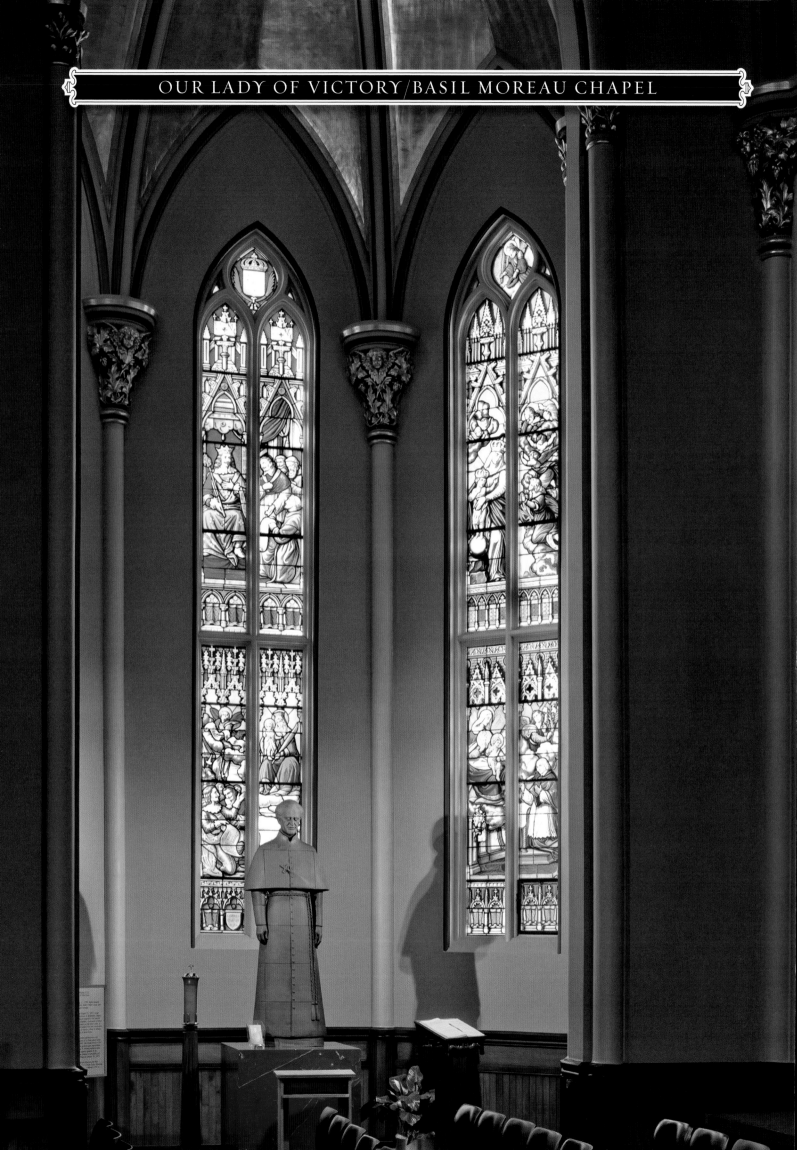

Dedicated to Our Lady of Victory, this chapel at one time housed the baptismal font that was designed originally in 1871 for Sacred Heart Church and is still used today at the front entrance of the Basilica.

In its place is a contemporary sculpture of Blessed Basil Moreau. The strikingly modern statue by the late Robert Graham was installed in 2007. Graham also created part of the Franklin Delano Roosevelt Memorial in Washington, D.C.

DATE BUILT:
1900

DEDICATION:
Our Lady of Victory

ACCESS:
During Basilica hours

Our Lady of Victory is also known as Our Lady of the Rosary, with the feast day celebrated on October 7th. The feast marks a day of thanksgiving for the defeat of the Ottoman Turks in the Battle of Lepanto at the entrance of the Bay of Corinth in 1571 by the combined forces of the so-called "Catholic League."

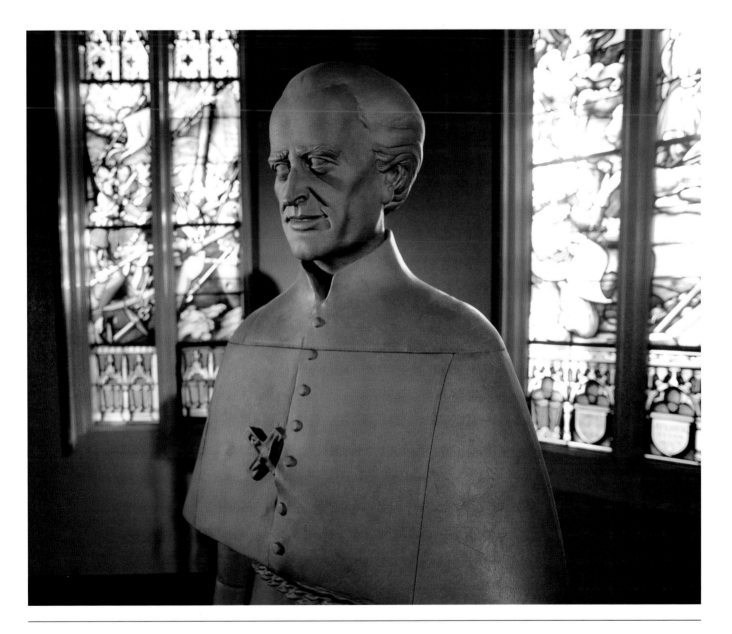

TOMB OF JOHN CARDINAL O'HARA, C.S.C.

DATE BUILT:
1900

DEDICATION:
Holy Cross

ACCESS:
During Basilica hours

Also popularly known as the O'Hara chapel, this chapel houses the sarcophagus of John Cardinal O'Hara, C.S.C., who was the thirteenth president of the University of Notre Dame. He later distinguished himself as the Archbishop of Philadelphia, after having served as head of all Catholic chaplains in World War II. A wonderful bronze of the "Return of the Prodigal Son" by Ivan Meštrović, given by the Knights of Columbus to honor the memory of Cardinal O'Hara, is also housed in the chapel.

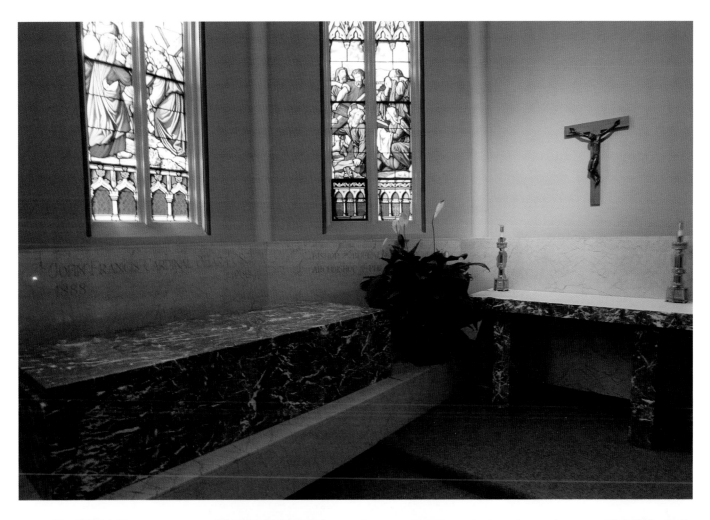

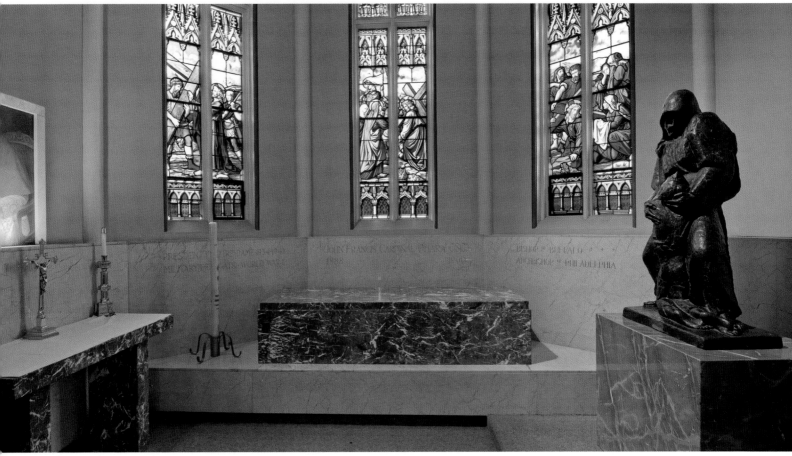

DATE BUILT:
1986

ACCESS:
By appointment

Located on the floor that houses storage, sacristy workshops, choir rooms, and so forth beneath the Basilica, this chapel, not open to the public, is of some interest because of the collection of episcopal regalia in cases that line the walls of the chapel. Behind the altar is a "golden screen"—a baroque section of woodwork salvaged from the church of Saint Bridget in Rome, which was once served by Holy Cross religious. Some of the vestments and liturgical materials such as mitres and croziers that are displayed in the cases date back to the nineteenth century.

TOP LEFT: *The "golden screen" salvaged from the church of Saint Bridget in Rome.*

BOTTOM LEFT: *Bishop's mitre.*

TOP RIGHT: *Bishop's crozier.*

The University of Notre Dame has always been primarily a residential university. The residence halls on campus each have a rector (priest, religious brother or sister, or layperson) in addition to a hall staff of assistants, as well as priests who may be in residence. All of the halls have a chapel where the Blessed Sacrament is reserved, Mass is regularly celebrated, and prayer services are held on a regular basis. Those services are often student inspired and led. Residents take on the responsibility of providing musicians, readers, and Eucharistic ministers. All residence halls have had designated chapels built within them since the first halls of the nineteenth century. The ideal of the university has always been to create Christian communities in the halls for which learning, social interaction, and worship form an integral part of the Notre Dame experience, centered around the proximity of the Eucharistic Christ in the chapels. Over the decades, the chapels in the older buildings have been redesigned to account for the liturgical changes mandated by the Second Vatican Council, while chapels built since Vatican II have been designed with the new liturgical requirements in mind.

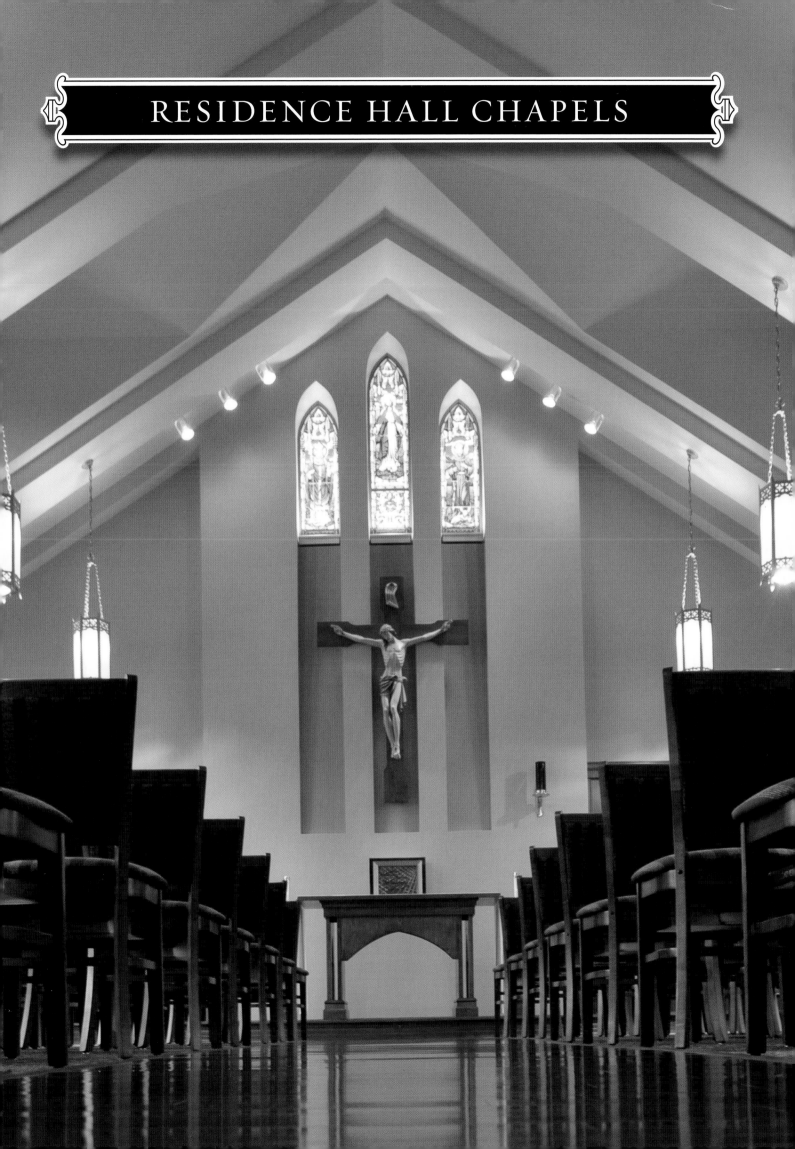

DATE BUILT:
1931

DEDICATION:
Saint Charles Borromeo

ACCESS:
By appointment

Robert Leader (1924–2006), a Marine hero who fought at Iwo Jima, has work in both Alumni and Sorin Halls. His art is also found in the stained glass windows of Saint Matthew's Cathedral in South Bend and in the murals of the Stations of the Cross in Little Flower Catholic Church in South Bend.

The chapel of Alumni Hall, dedicated in honor of Saint Charles Borromeo in 1931, is rich in artistic ornament. The stained glass windows that flank the tabernacle are dedicated to the Blessed Virgin Mary and Saint Charles Borromeo. The wall windows honoring the Blessed Virgin under the titles of Our Lady of Purity, Our Lady of Perseverance, Our Lady of Good Studies, and Our Lady of Wisdom are the work of the late Notre Dame art professor Robert Leader. The Stations of the Cross come from the great wood-carving area of Oberammergau in Germany. Saint Charles Borromeo (1538–1584) is commemorated in the liturgy on November 4th.

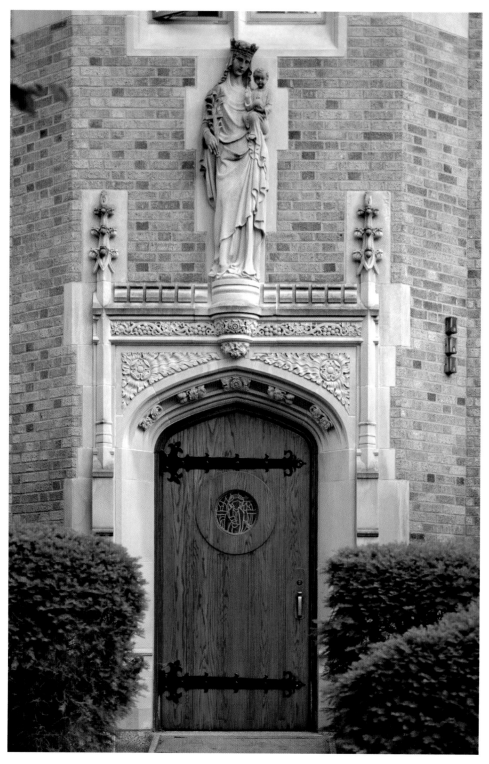

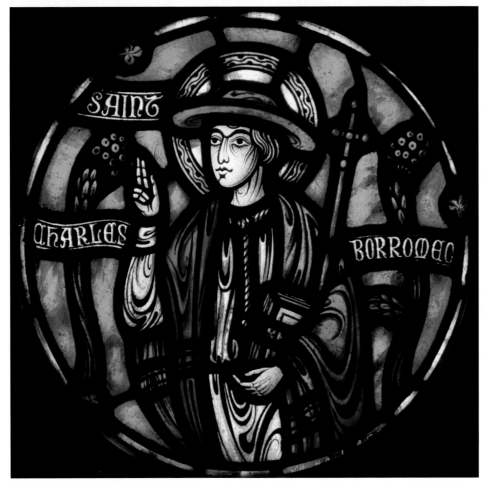

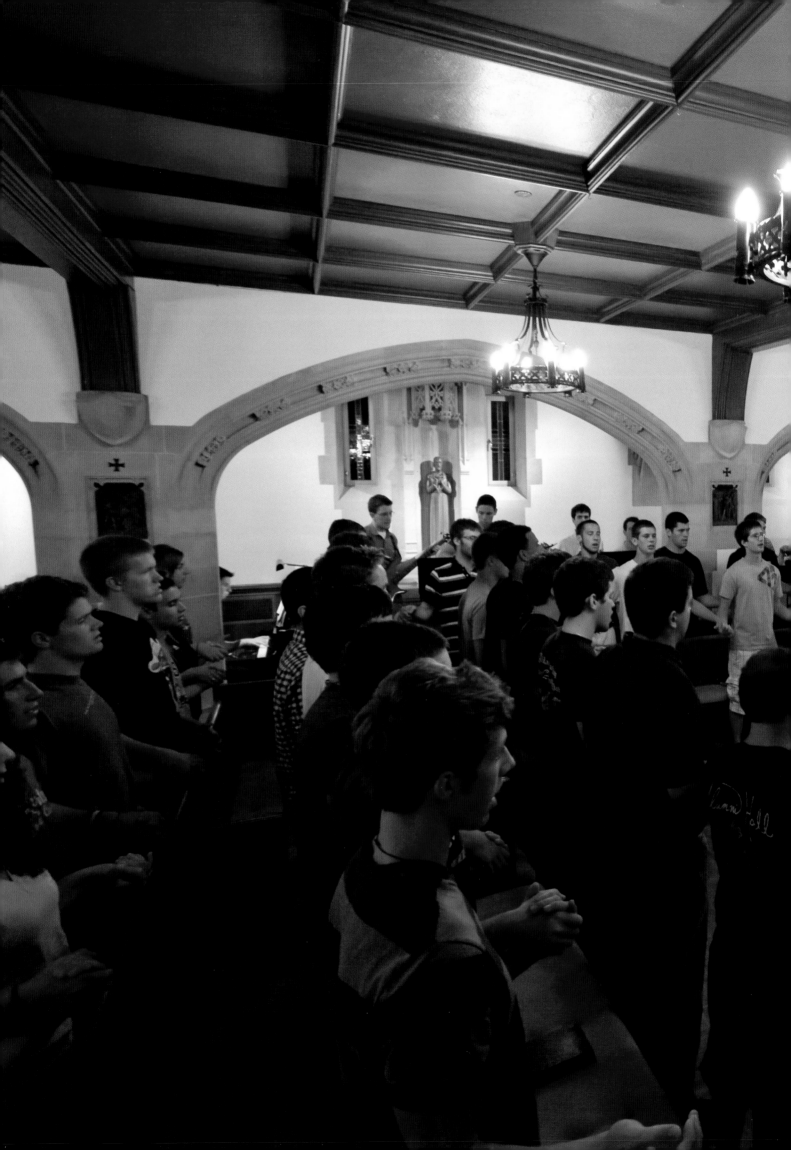

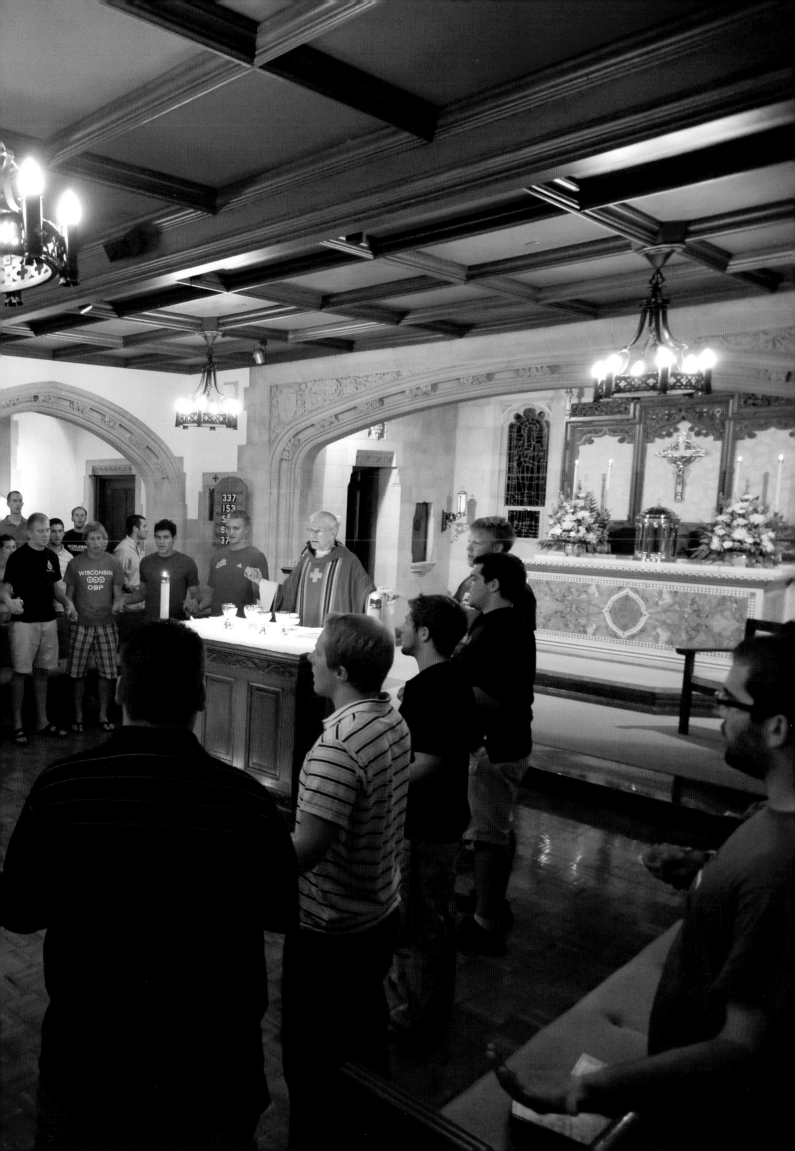

DATE BUILT:
1897

DEDICATION:
Saint Stephen

ACCESS:
By appointment

Built in 1897 as an industrial school for boys, Badin Hall became a men's residence hall in 1917 and was converted into a women's residence in 1972. The chapel, under the patronage of Saint Stephen, honors Father Stephen Badin (1768–1853), who was the first priest ordained in the United States. Father Badin had donated land north of South Bend to the Bishop of Vincennes (Indiana). It was that land upon which the University of Notre Dame was built. Badin's remains now rest under the Log Chapel on Notre Dame's campus.

Saint Stephen's ministry and death by stoning is described in Acts 6–7. Stephen is considered the first Christian martyr. His feast is celebrated on December 26th.

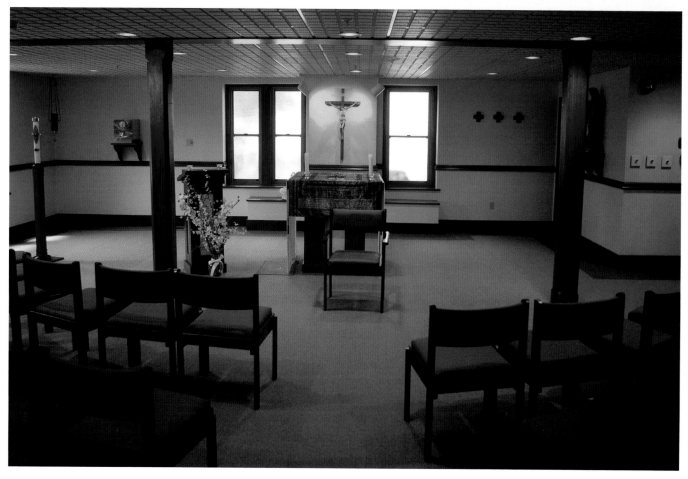

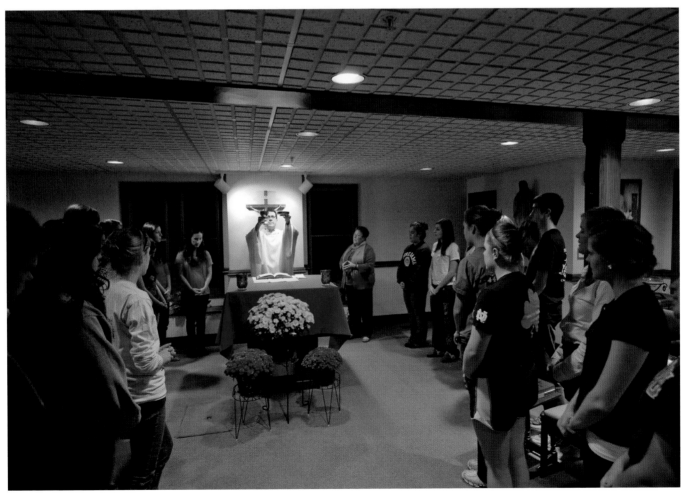

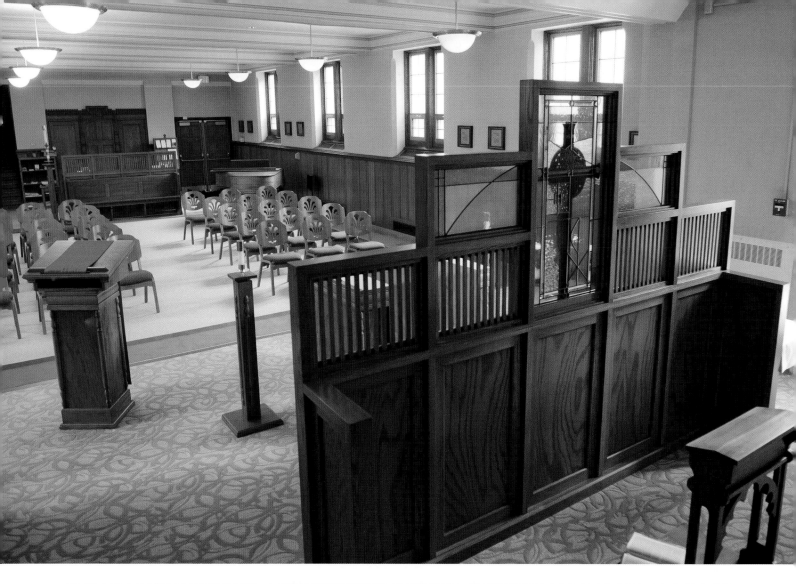

Saint Francis of Assisi (1181–1226) was originally baptized with the name John, but his father renamed him Francesco— the "Little Frenchman"— to honor the country where his father often traveled as a cloth merchant. Saint Francis is known as the patron saint of animals.

Constructed in 1939, the chapel was originally dedicated to Saint William but is now under the patronage of Saint Francis of Assisi. The original sanctuary is now behind a screen, and its altar serves as the Blessed Sacrament repository. The present altar is on the west side of the chapel, oriented toward the east. On the right side of the wall at the entrance of the chapel is a contemporary banner of Saint Francis.

DATE BUILT:
1939

DEDICATION:
Saint Francis of Assisi (originally Saint William)

ACCESS:
By appointment

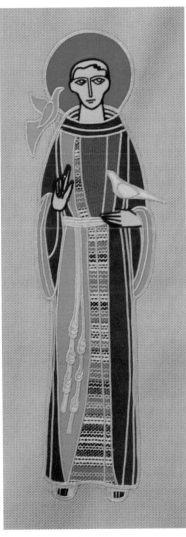

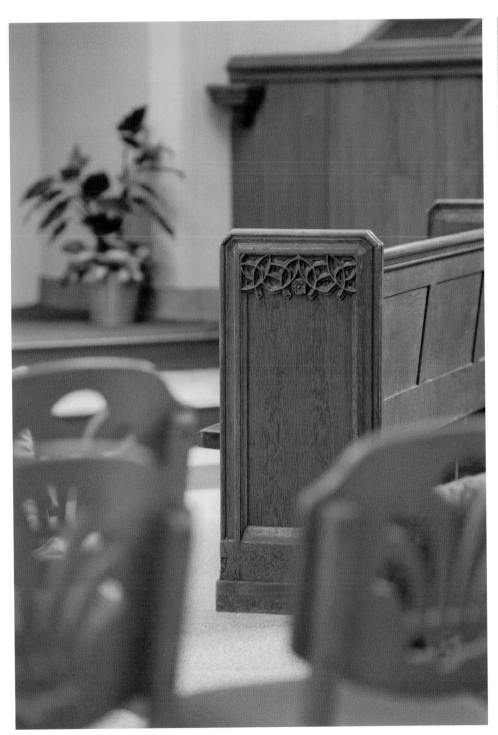

DATE BUILT:
1906

DEDICATION:
*Saint André Bessette
(originally Saint James)*

ACCESS:
By appointment

Carroll Hall was built in 1906–1907 to serve as a House of Studies for the Holy Cross brothers. The chapel was under the patronage of Saint James, to honor Rev. James Dujarie, the founder of the brothers. The university acquired the building from the brothers in the 1960s. It served first as a residence for graduate students and in 1977 was made into a residence for undergraduate men. It is named for Charles Carroll, the only Catholic signer of the Declaration of Independence.

In 2010 the chapel was rededicated to Saint André Bessette, a Holy Cross brother who was canonized by Pope Benedict XVI in that year. The pews come from the old Moreau Seminary chapel, currently the Sacred Heart Parish Center; the stained glass windows are from the chapel of the torn-down minor seminary, Holy Cross Seminary.

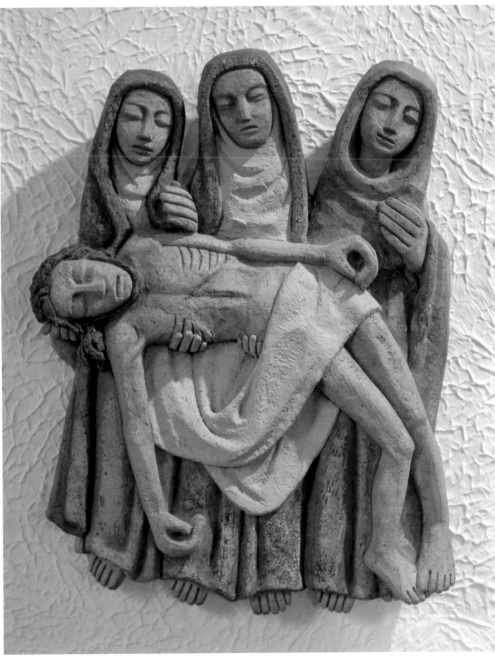

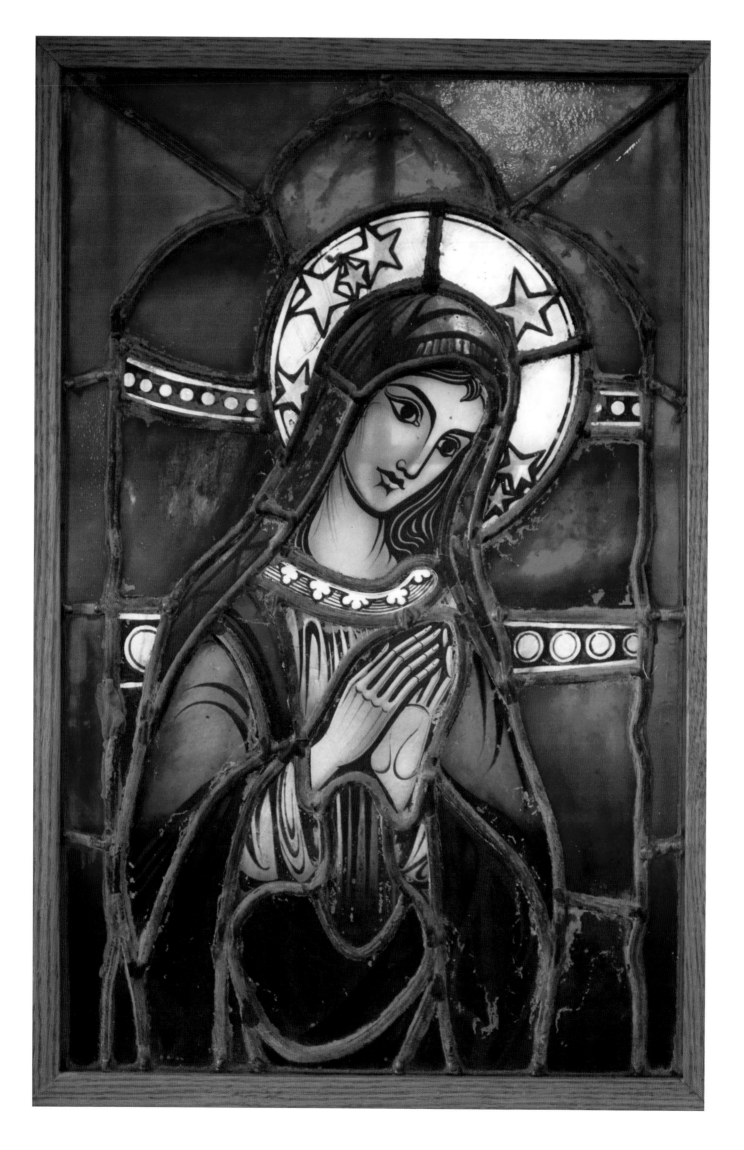

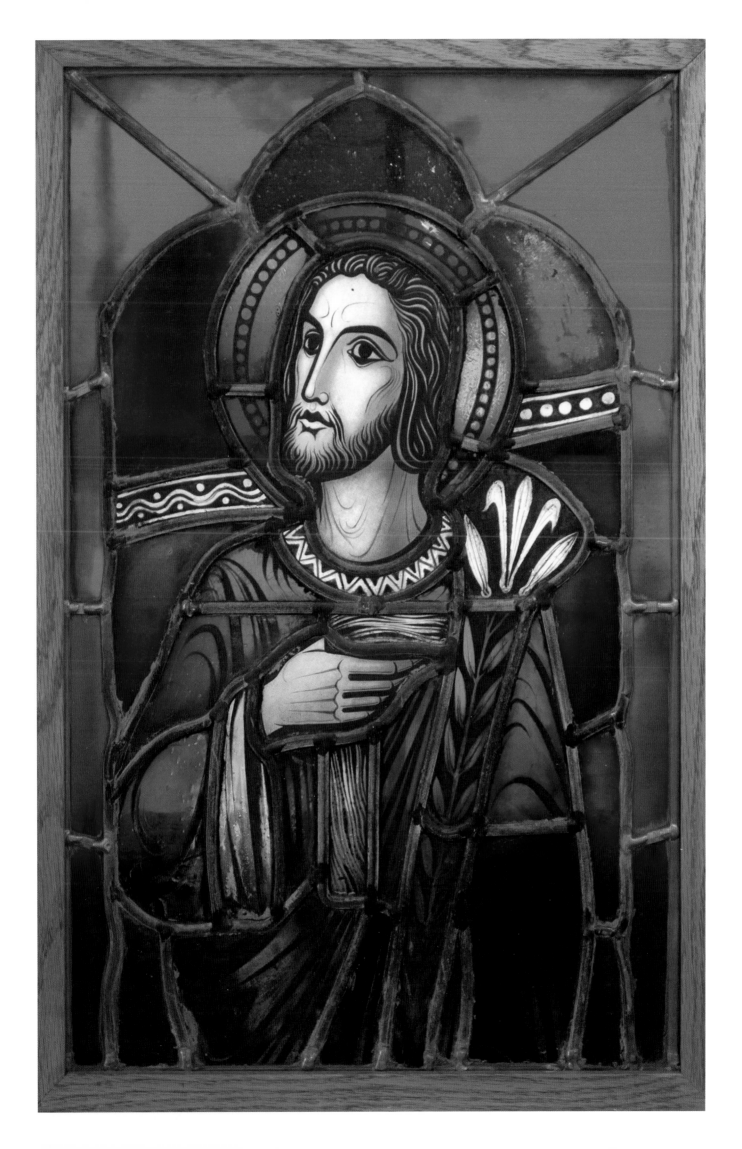

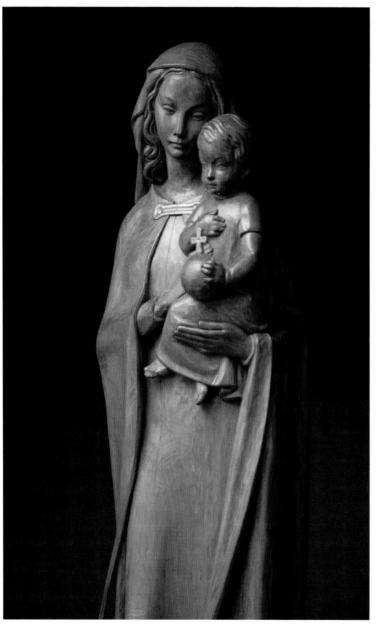

Named in honor of Rev. John W. Cavanaugh, C.S.C., who was president of Notre Dame from 1905 to 1919, the hall was built in 1936. The chapel is dedicated to the Holy Spirit. At the right of the entrance to the chapel is a beautiful bas-relief sculpture of the Sorrowful Mother holding a crown of thorns. The main altar is separated from the Blessed Sacrament chapel by a wood screen within which is a handsome cross in stained glass. On the arch of the sanctuary is a relief of the symbol of the Holy Spirit flanked by two adoring angels.

DATE BUILT:
1936

DEDICATION:
Holy Spirit

ACCESS:
By appointment

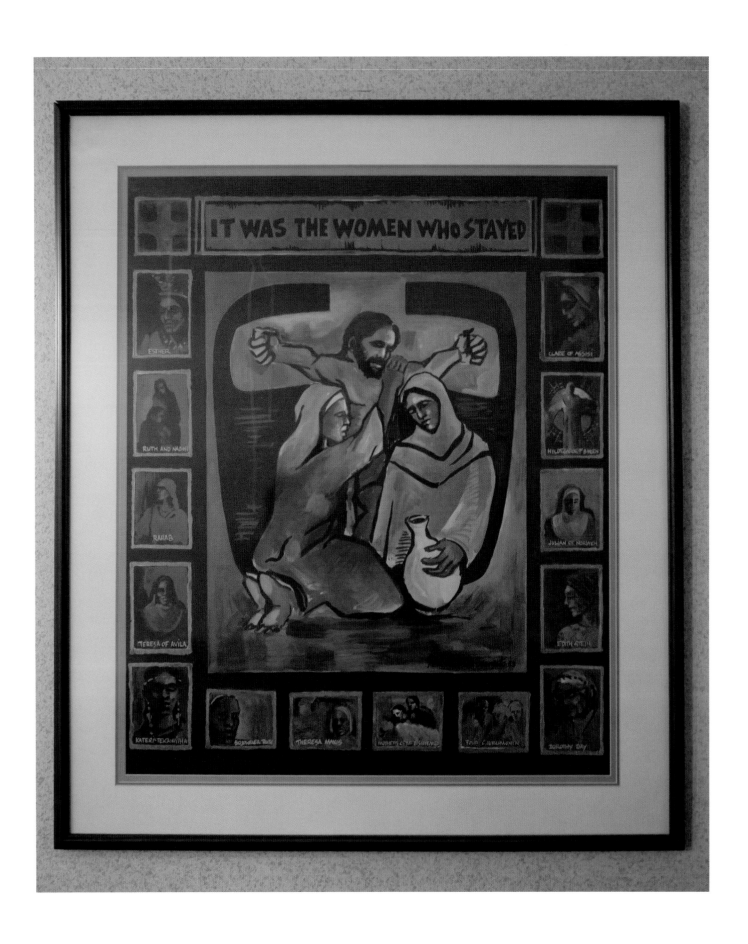

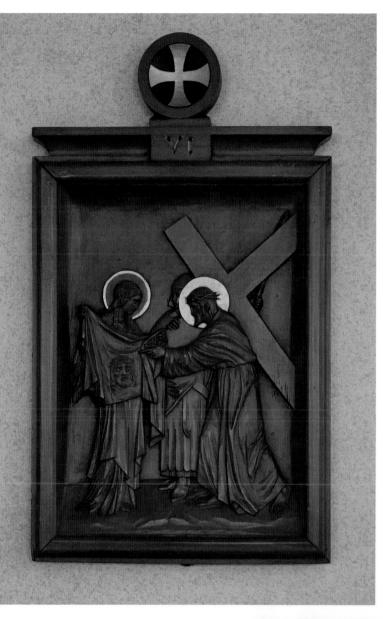

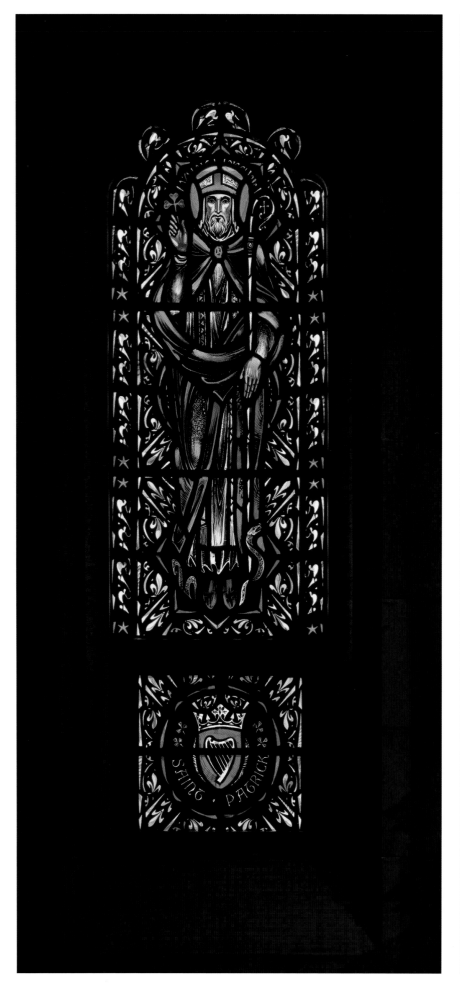

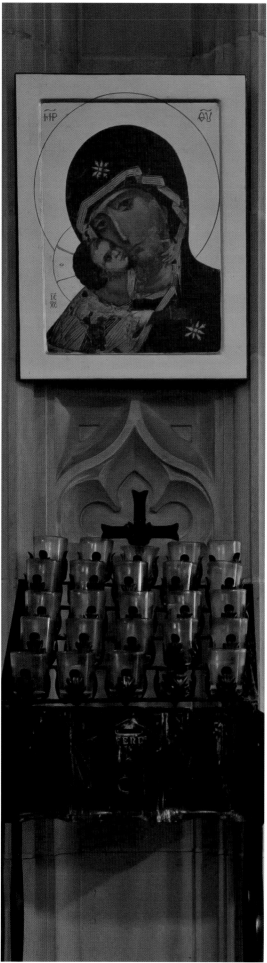

✢ *The Chapels of Notre Dame* ✢

Rev. Patrick Dillon, C.S.C., was the second president of the University of Notre Dame, assuming office in 1865. Dillon Hall and its chapel were dedicated in 1931. Of particular interest are the stunning stained glass windows. On the left side of the chapel are three windows honoring Saints Augustine of Hippo, Bernard of Clairvaux, and Benedict. On the right side are Saints Ignatius of Loyola, Francis of Assisi, and Dominic. Flanking the Blessed Sacrament altar are, on the left, Saint Patrick (to whom the chapel is dedicated) and, on the right, Saint Brigid of Kildare.

To the left of the Blessed Sacrament altar is a lovely icon of Mary and the Child Jesus done in the Byzantine style, known as the Vladimir Icon. Before the icon is a stand for vigil lights.

DATE BUILT:
1931

DEDICATION:
Saint Patrick

ACCESS:
By appointment

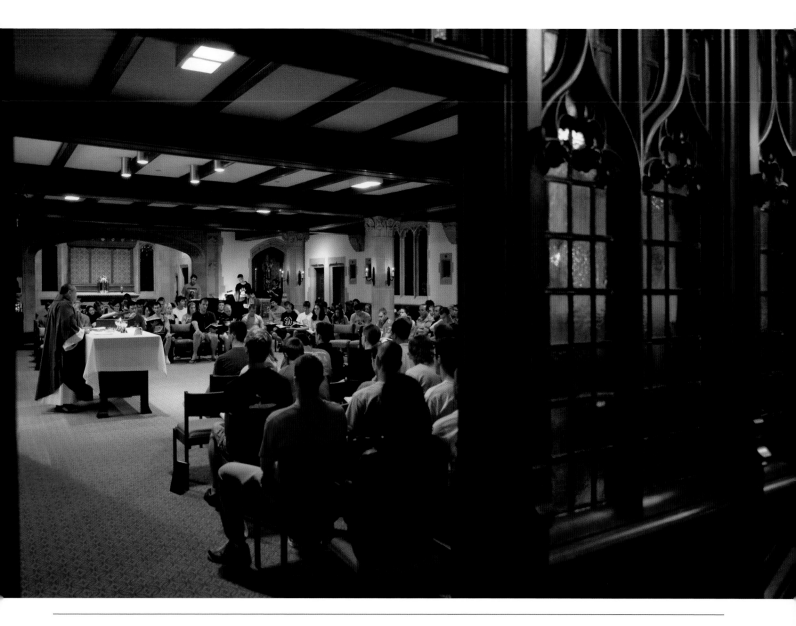

DATE BUILT:
2008

DEDICATION:
Saint Walter

ACCESS:
By appointment

Dedicated in 2008, the chapel is under the patronage of the eleventh-century monk Saint Walter of Pontoise (died 1095). The chapel is on the second floor of the building, which allowed the architect to provide it with high cathedral ceilings. In the apse are three lancet windows that stand above the main crucifix over the altar: on the left, Saint Patrick; in the center, Our Lady; and on the right, Saint Francis of Assisi. The Stations of the Cross are framed so as to echo the much larger frames of the Stations in the Basilica of the Sacred Heart on campus.

> *Saint Walter was canonized in 1153 by the Archbishop of Rouen in France. He is the last saint to be canonized by a bishop before the canonization process was made exclusively the prerogative of the pope. Saint Walter's feast day is on April 8th.*

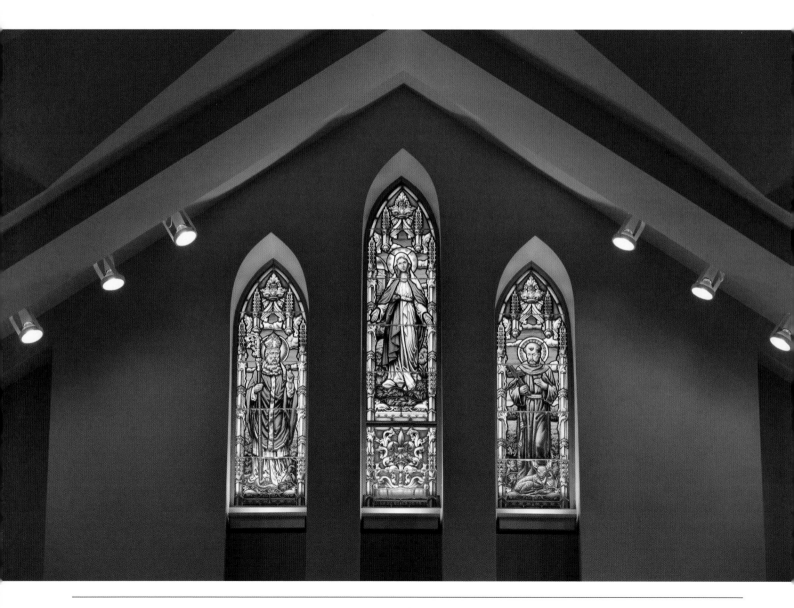

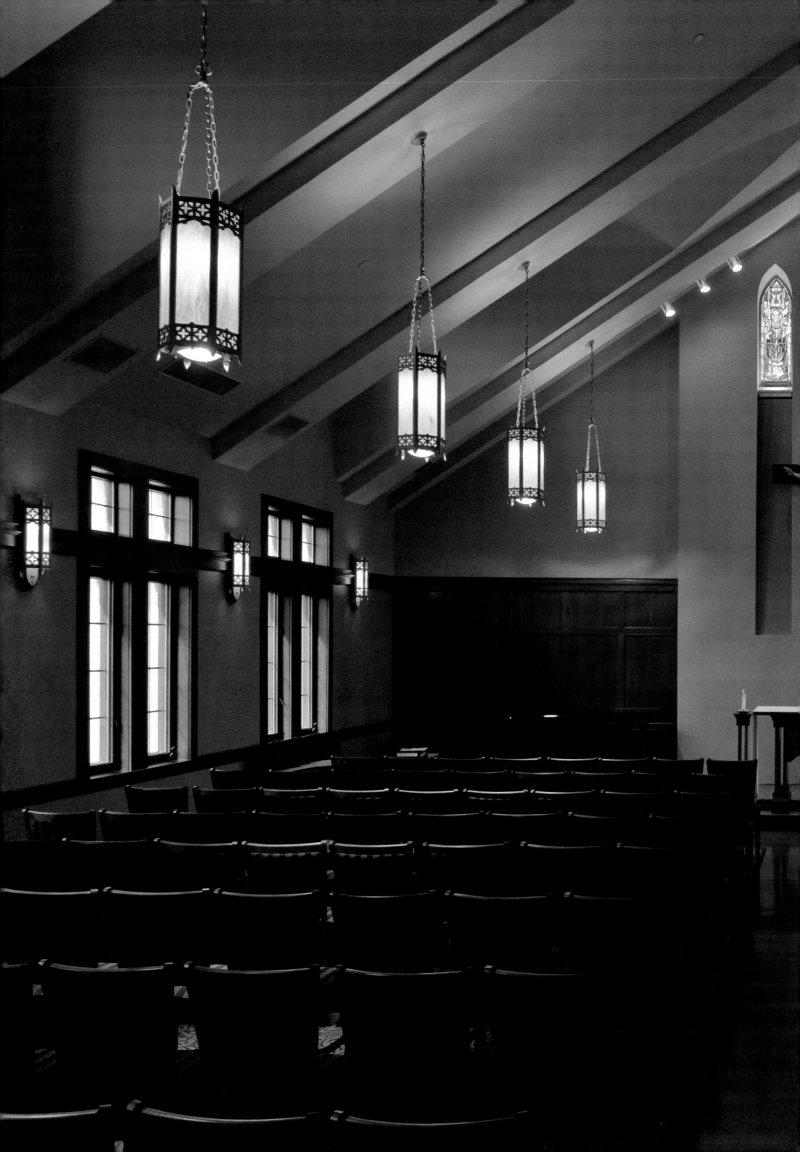

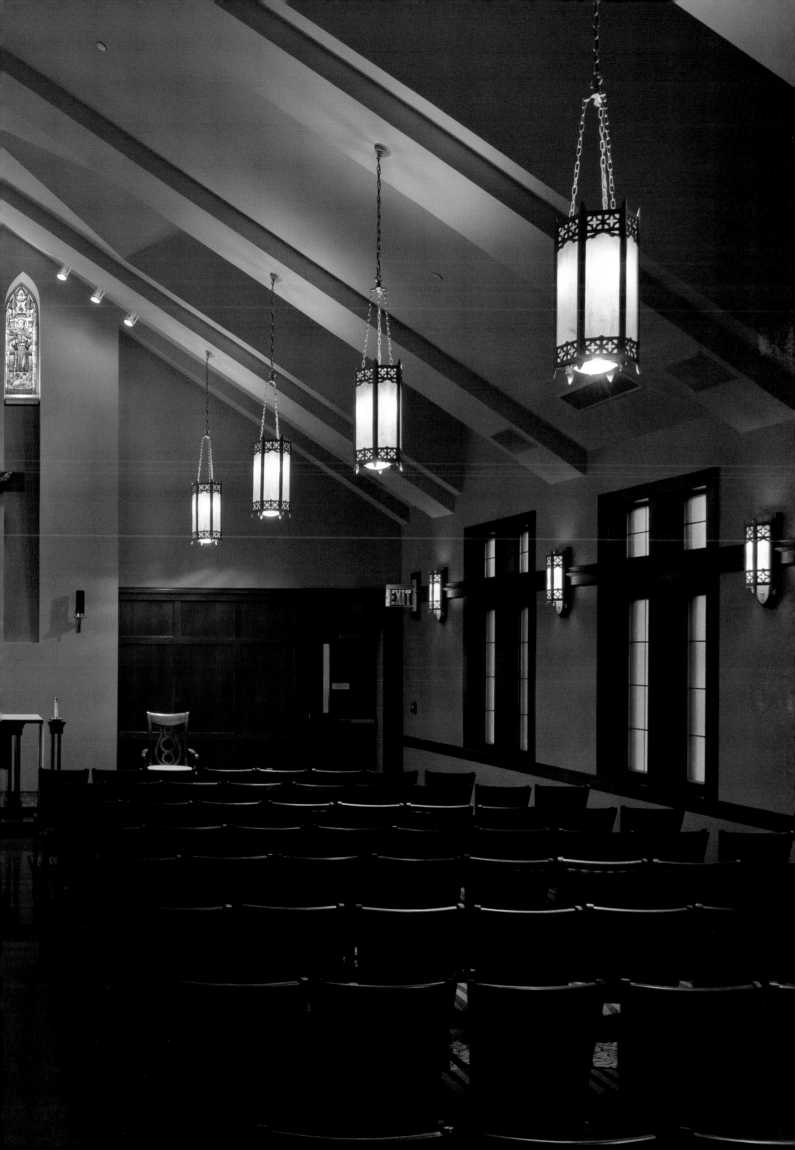

DATE BUILT:
1947

DEDICATION:
Saint John the Evangelist

ACCESS:
By appointment

The chapel was dedicated in 1947 to Saint John the Evangelist to honor the late Rev. John "Pop" Farley, C.S.C. Like the chapel in Breen-Phillips, the Blessed Sacrament altar is separated from the main worship space by an attractive wooden screen. To the left of the main altar is a small replica of the statue of the Visitation that stands outside the entrance of the campus bookstore. The feast of Saint John the Evangelist (also called John the Apostle) is on December 27th.

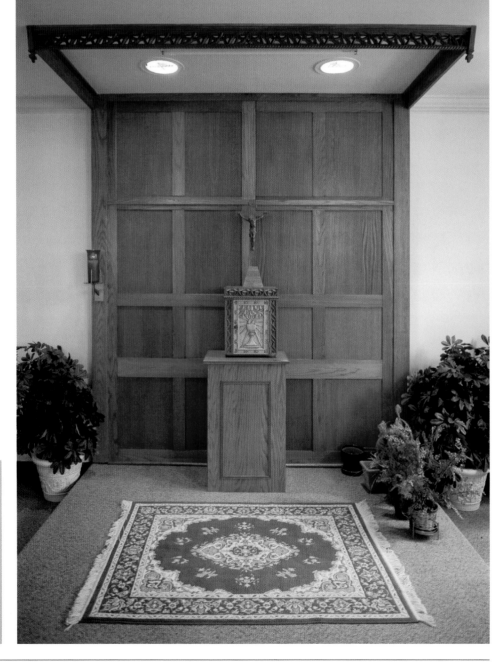

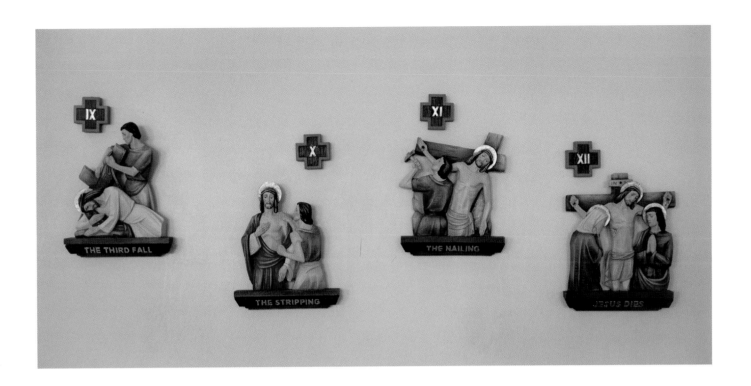

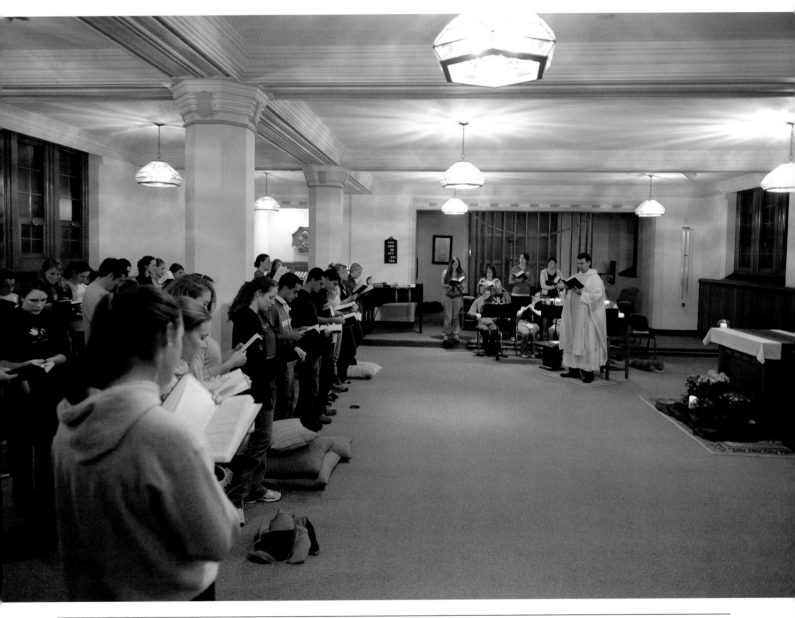

The graduate residences were built in 1991. The chapel is dedicated to Saint Catherine of Alexandria, who is the patroness both of single women and of philosophers. Catherine was reputed to have a gift for explaining the faith to nonbelievers. Her symbol is a wheel, upon which she was tortured before she was beheaded.

DATE BUILT:
1991

DEDICATION:
Saint Catherine of Alexandria

ACCESS:
By appointment

Much of what the tradition says about Saint Catherine is of a legendary character. Her feast day is November 25th, observed as an optional memorial in the 2002 Roman Missal, third edition.

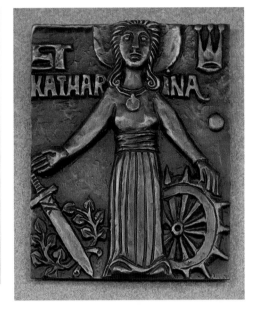

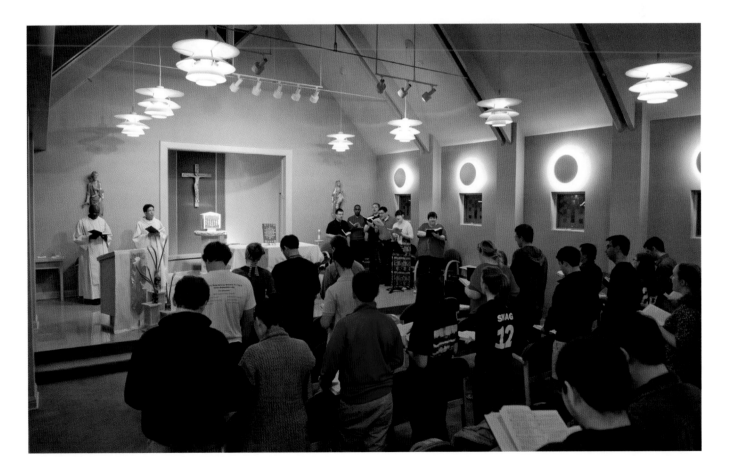

DATE BUILT:
1953

DEDICATION:
Saint Paul the Apostle

ACCESS:
By appointment

Dedicated in 1953, the chapel of Fisher Hall is under the patronage of Saint Paul the Apostle. Framing the altar where the tabernacle rests are two windows with Eucharistic motifs: cup and grapes to the left and sheaves of wheat with a host over the cup on the right. The chapel has a beautiful bas-relief sculpture of Saint Paul, easily recognizable by the sword he holds, which alludes to the scriptural line that the Word of God is like a two-edged sword (Heb 4:12).

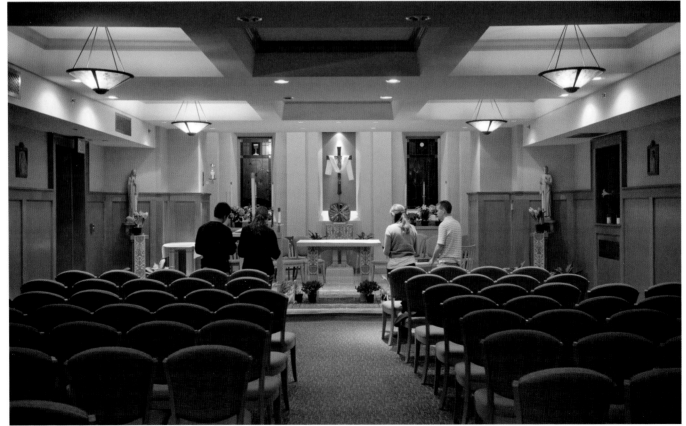

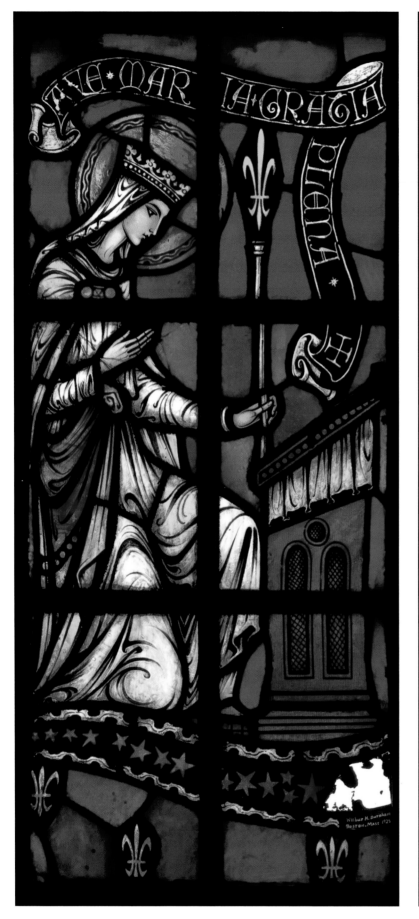

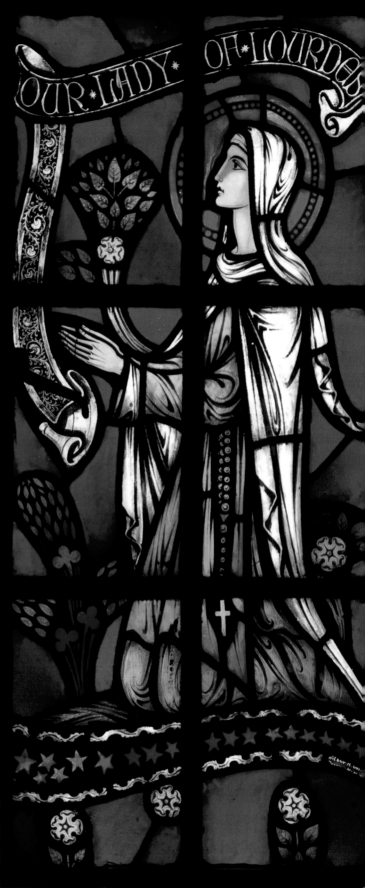

Howard Hall was dedicated in 1924 with its chapel under the patronage of Our Lady of Lourdes. Her image is to the right in a stained glass window flanking the main altar (the window on the left commemorates the Annunciation). Of particular artistic interest is the sculpture of the Pietà on the right wall of the chapel. The side windows depict symbols of Our Lady. Visitors should pay attention to the carved granite framing the reredos behind the main altar and the niche for the sanctuary lamp in the Blessed Sacrament altar to the left of the main altar.

DATE BUILT:
1924

DEDICATION:
The Immaculate Conception of Our Lady of Lourdes

ACCESS:
By appointment

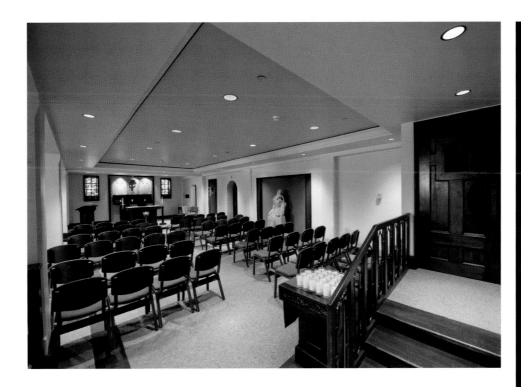

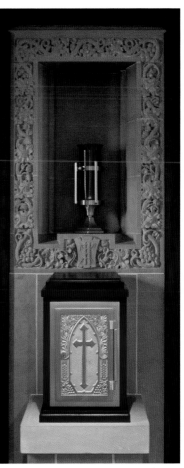

DATE BUILT:
1957

DEDICATION:
Holy Cross

ACCESS:
By appointment

Constructed in 1957, this is the only chapel on campus that serves two residence halls. The Holy Cross chapel of Keenan and Stanford also has the honor of being the first chapel to enjoy air conditioning, setting a precedent. All subsequent residence halls built for students enjoy that comfort. The crucifix over the main altar is by Ivan Meštrović.

Because of its large size, it is very popular with undergraduate students, who love to attend its liturgies. A *Scholastic* magazine article in 2011 voted it one of the four best chapels to attend for the Sunday liturgy.

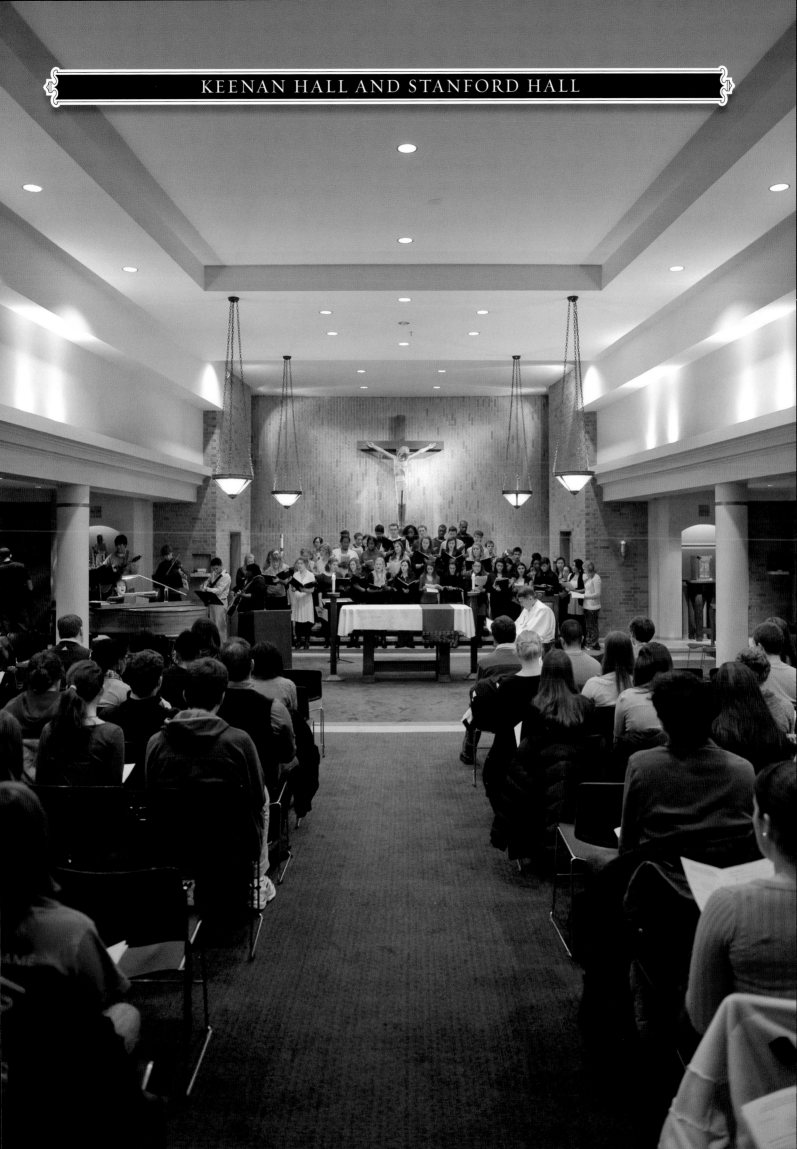

DATE BUILT:
1996

DEDICATION:
Our Lady of Guadalupe

ACCESS:
By appointment

This hall and its chapel were dedicated in 1997. The chapel is dedicated to Our Lady of Guadalupe, whose feast is on December 12th. The grand piano was placed in the chapel after it was moved from its previous location in Grace Hall. The beautiful wall hanging to the right, facing the altar, depicts various interpretations of Our Lady of Guadalupe. The university had more than one reason to dedicate the chapel to Our Lady of Guadalupe: it is a tribute to the increasing number of Hispanic students; it fulfills a desire to honor more women saints; and, finally, the donor's patron is Mary.

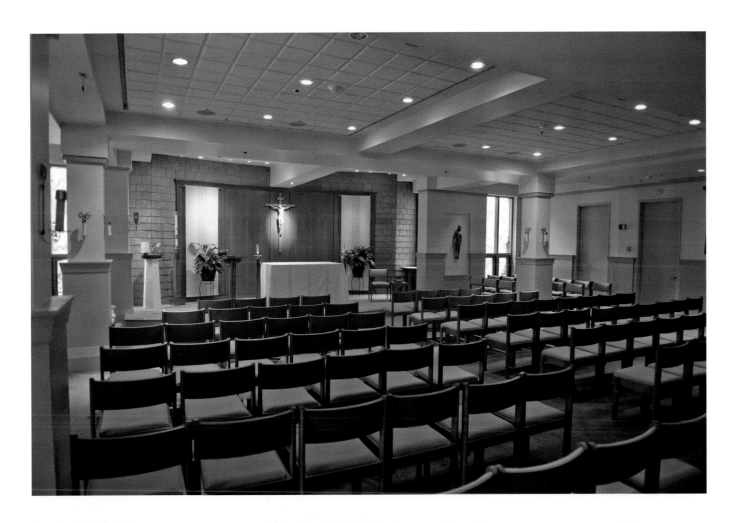

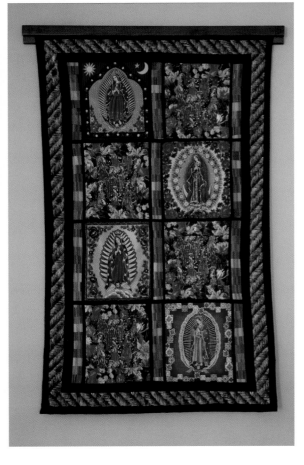

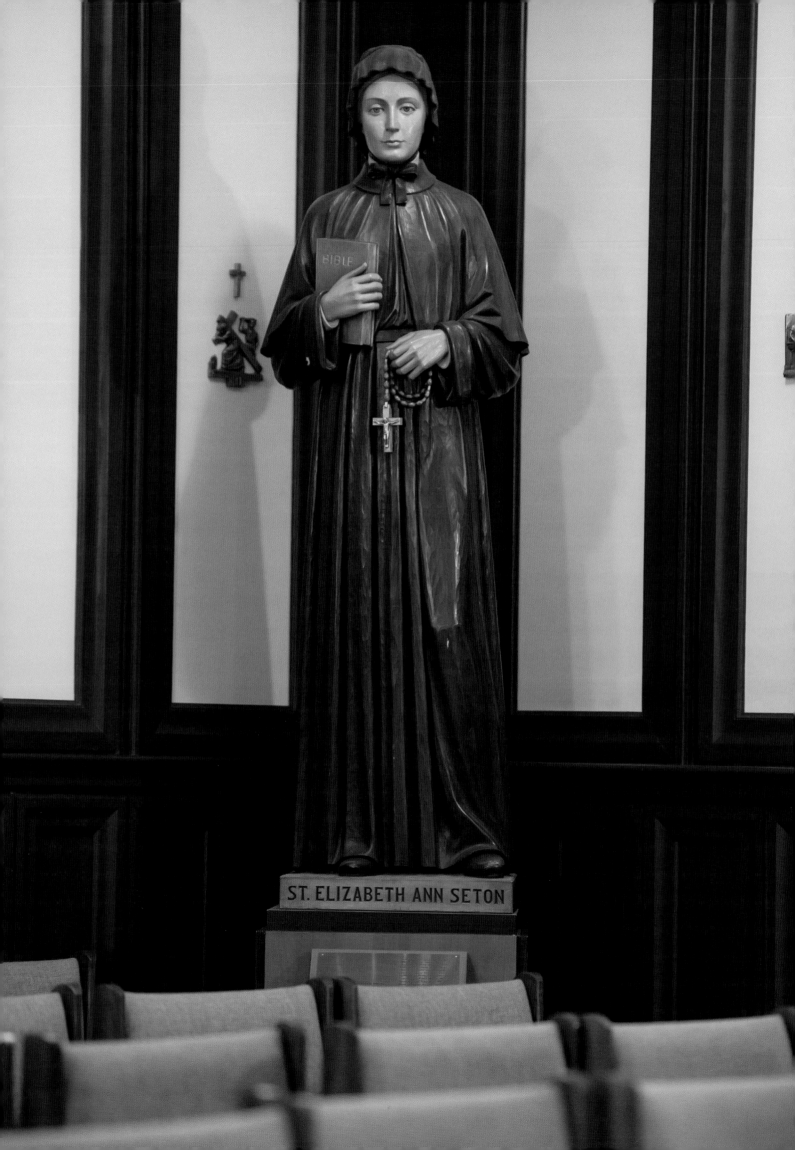

ST. ELIZABETH ANN SETON

This chapel was dedicated in 1988 under the patronage of Saint Elizabeth Ann Seton (1774–1820), the first American-born person canonized (in 1975 by Pope Paul VI). The chapel holds two very important artworks. In the back is a bas-relief sculpture in wood of the sorrowing women at the foot of the cross, by Ivan Meštrović. To the left of the main altar is a life-sized statue of Elizabeth Ann Seton donated by Archbishop Robert J. Seton, the saint's grandson. Saint Elizabeth's bible is held in the archives of the University of Notre Dame.

DATE BUILT:
1988

DEDICATION:
Saint Elizabeth Ann Seton

ACCESS:
By appointment

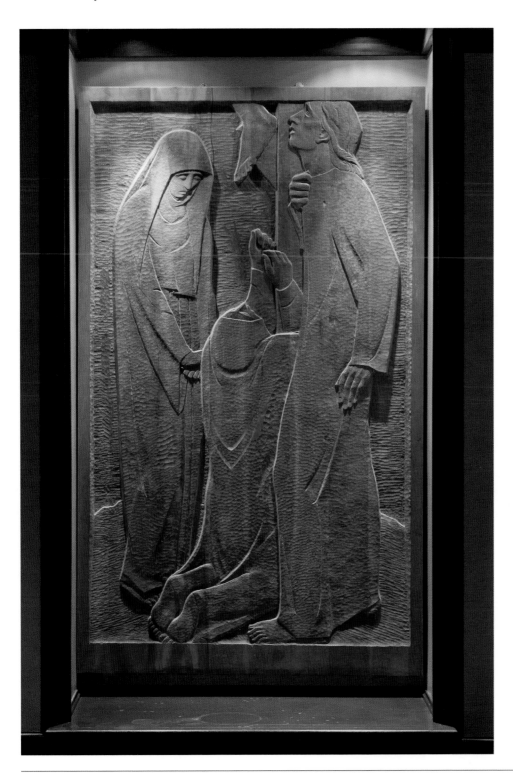

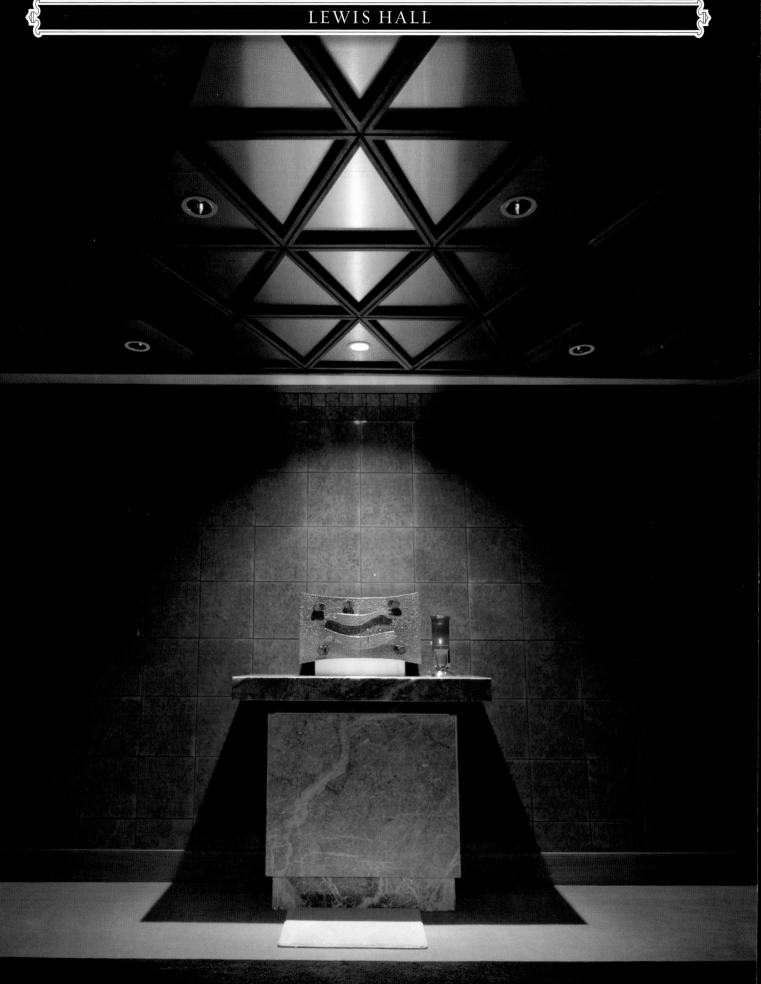

Dedicated to Saint Teresa of Avila, this roomy chapel has a half-moon arrangement of chairs in front of the ambo and altar. An attractive freestanding reredos of wood separates the altar area from the tabernacle where the Blessed Sacrament is reserved. On the back wall, left to right, are bronze figures of the Blessed Virgin Mary and Saint Joseph. During the academic term the students organize a lucernarium (lamp-lighting) vesper service once a week, which residents and others from various halls may attend.

DATE BUILT:
1965

DEDICATION:
Saint Teresa of Avila

ACCESS:
By appointment

Saint Teresa of Avila, whose feast is on October 15th, is one of the first women to be named (in 1970 by the late Pope Paul VI) a Doctor of the Church.

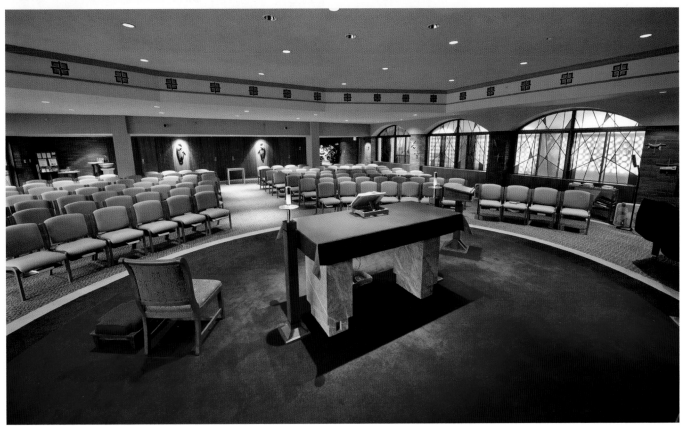

DATE BUILT:
1925

DEDICATION:
All Souls

ACCESS:
By appointment

Named in honor of Joseph Lyons, a distinguished professor of literature who died in 1888 (the first layperson buried in the Holy Cross community cemetery), the hall was built in 1925. The chapel is dedicated to All Souls, and the stained glass window of Pope Gregory the Great (died 604) alludes to the custom of celebrating thirty Masses for a deceased person, a practice first mentioned by Gregory. There has long been a custom for the residents to lay a wreath and offer prayers at Professor Lyons' grave on All Souls Day. The Latin American cross in the chapel was a gift in memory of Mara Fox from members of her Spanish class. Mara was killed in 1993 when she was hit by a car while walking to campus. The famous archway outside of Lyons has a statue of Saint Joseph the Worker in a niche above the apex of the arch.

DATE BUILT:
1997

DEDICATION:
Saint Bridget of Kildare

ACCESS:
By appointment

The woman's name "Bridget" means "Exalted One" and before the Christianization of Ireland was a common name for the pagan sun goddess.

McGlinn Hall was opened in 1997 for women residents. The chapel is dedicated to Saint Bridget (also spelled: Brigit; Brigid; Brida; Bergitta) of Kildare (450–525). Baptized by Saint Patrick, this Irish abbess presided over a "double monastery" of men and women. She is the patroness of Ireland. She is known as "Mary of the Gaels"—an appropriate saint for a university that describes itself as the home of the "Fighting Irish." Her feast day is February 1st.

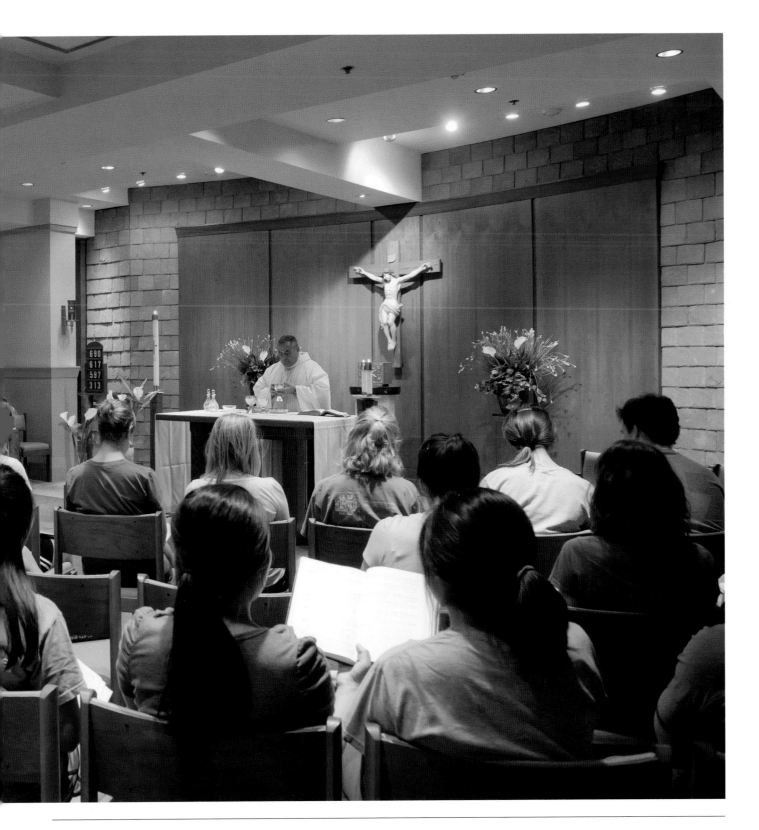

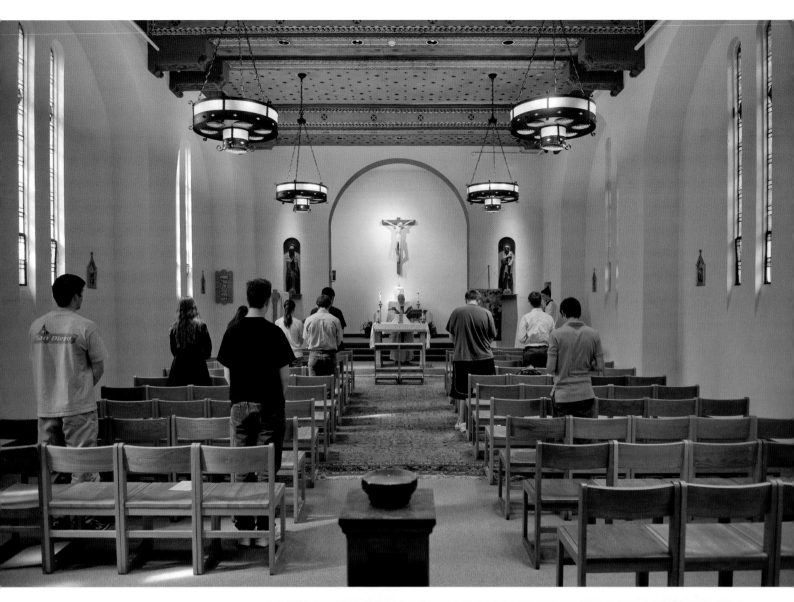

✚ *The Chapels of Notre Dame* ✚

The chapel of Morrissey Hall dates from 1925. It was the first chapel on campus to be dedicated to a woman other than the Blessed Mother. Saint Thérèse of Lisieux (1873–1897) was canonized in that year and shortly thereafter was named patroness of all missionary activity in the Church. Saint Thérèse, also known as the "Little Flower," was named a Doctor of the Church by Blessed John Paul II. Her feast is celebrated on October 1st. Morrissey Hall itself is named in honor of Rev. Andrew Morrissey, C.S.C., who served as Notre Dame's president from 1893 to 1905.

Morrissey Hall Chapel is also singular in that it was the first chapel on campus in which everything from the pews and altar to the statuary was done completely in oak.

DATE BUILT:
1925

DEDICATION:
Saint Thérèse of Lisieux

ACCESS:
By appointment

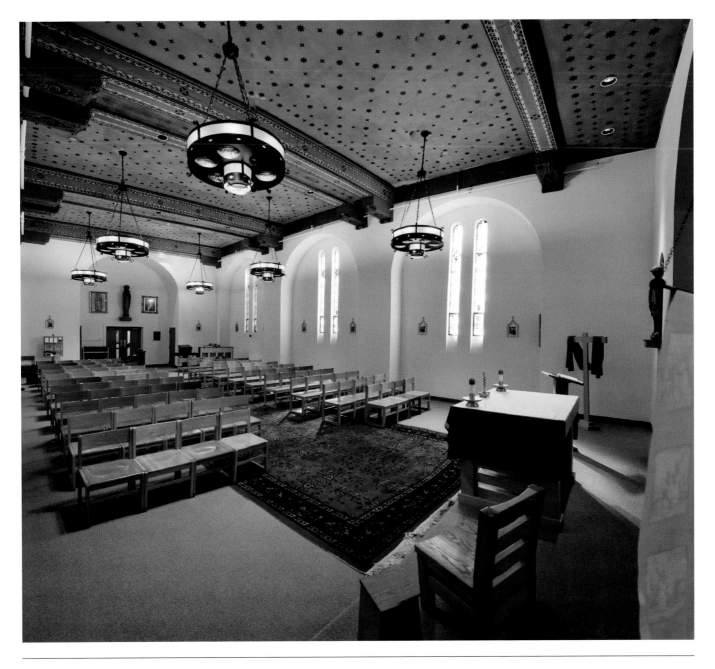

DATE BUILT:
1996

DEDICATION:
Saint Joseph the Worker

ACCESS:
By appointment

Dedicated in 1996, the chapel of O'Neill Hall is under the patronage of Saint Joseph the Worker. The triptych (late fourteenth-century Italian; canvas on wood) behind glass on the wall to the right is also a gift of the O'Neill family. Touchingly, students have placed, on the glass of the triptych, memorial cards of their classmates and friends who have died while in college. There are two feasts of Saint Joseph in the Roman calendar: March 19th and May 1st. The May feast was instituted in 1955 by Pope Pius XII with the suppression of the feast of Saint Joseph, Patron of the Universal Church, established by Pope Pius IX in 1870. Pius XII chose May 1st as an alternative to the celebration of International Workers' Day and its association with Communism.

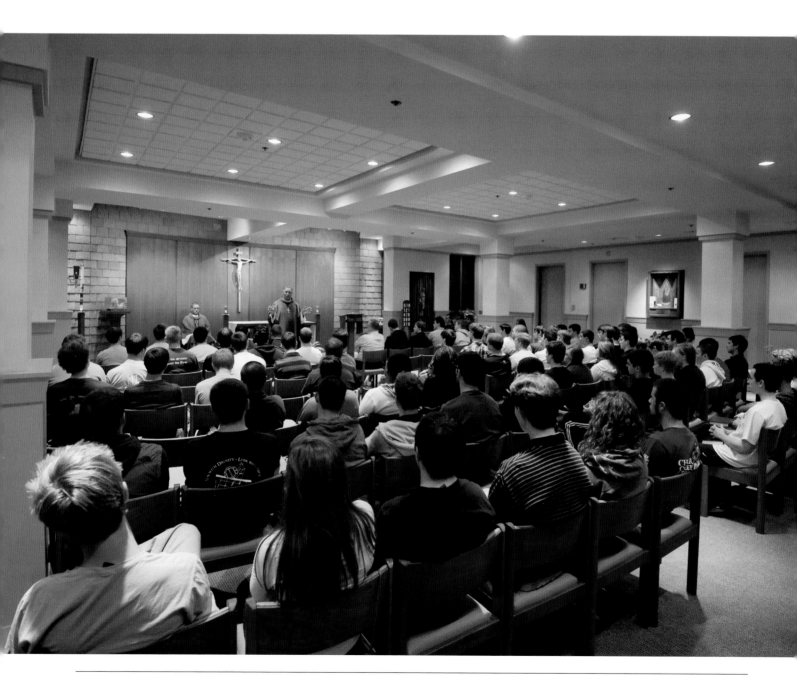

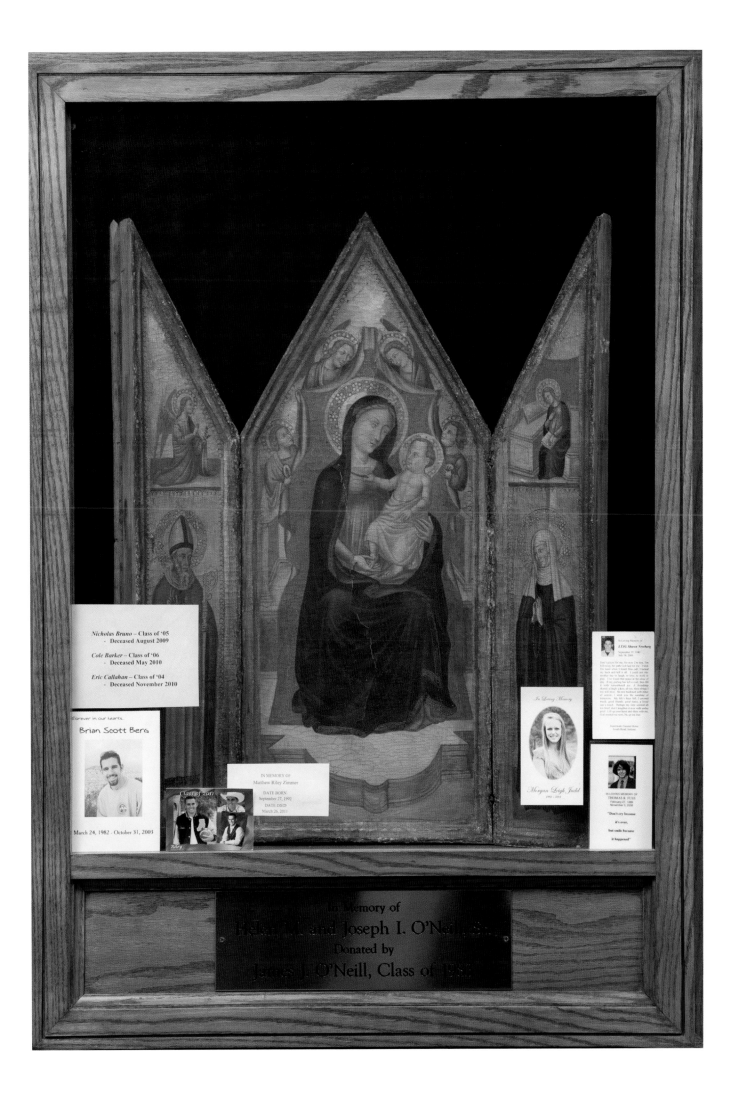

DATE BUILT:
1955

DEDICATION:
*The Annunciation
(originally Saint Pius X)*

ACCESS:
By appointment

Pangborn Hall was built in 1955, and the chapel is dedicated to the Annunciation. The chapel was completely redone in 1995 by the architect Jed Eide, who also designed the windows that repeat the lily motif—a flower associated with the Blessed Virgin. The walls are faced with green glazed brick, which gives the chapel as a whole a bright look. The feast of the Annunciation of the Lord is celebrated on March 25th.

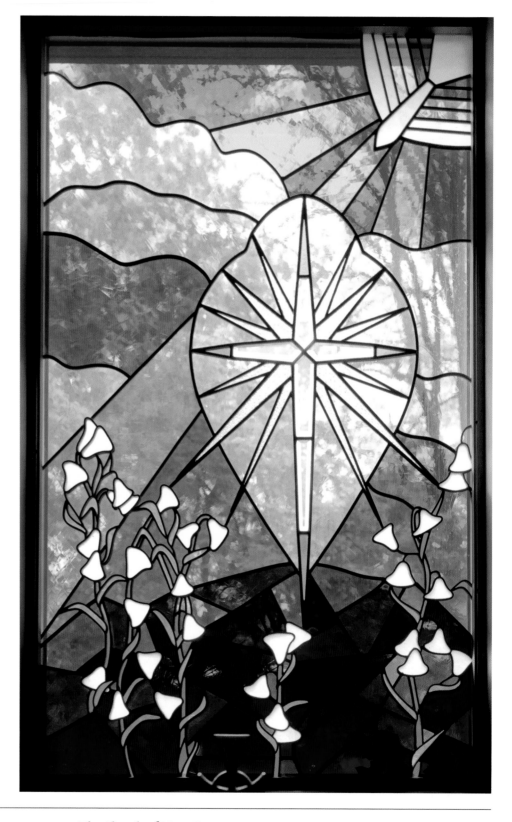

Pangborn chapel was originally dedicated to Saint Pius X,
who had been canonized the year before the hall was built.
The chapel was renamed after renovations and the installation
of the Visitation window.

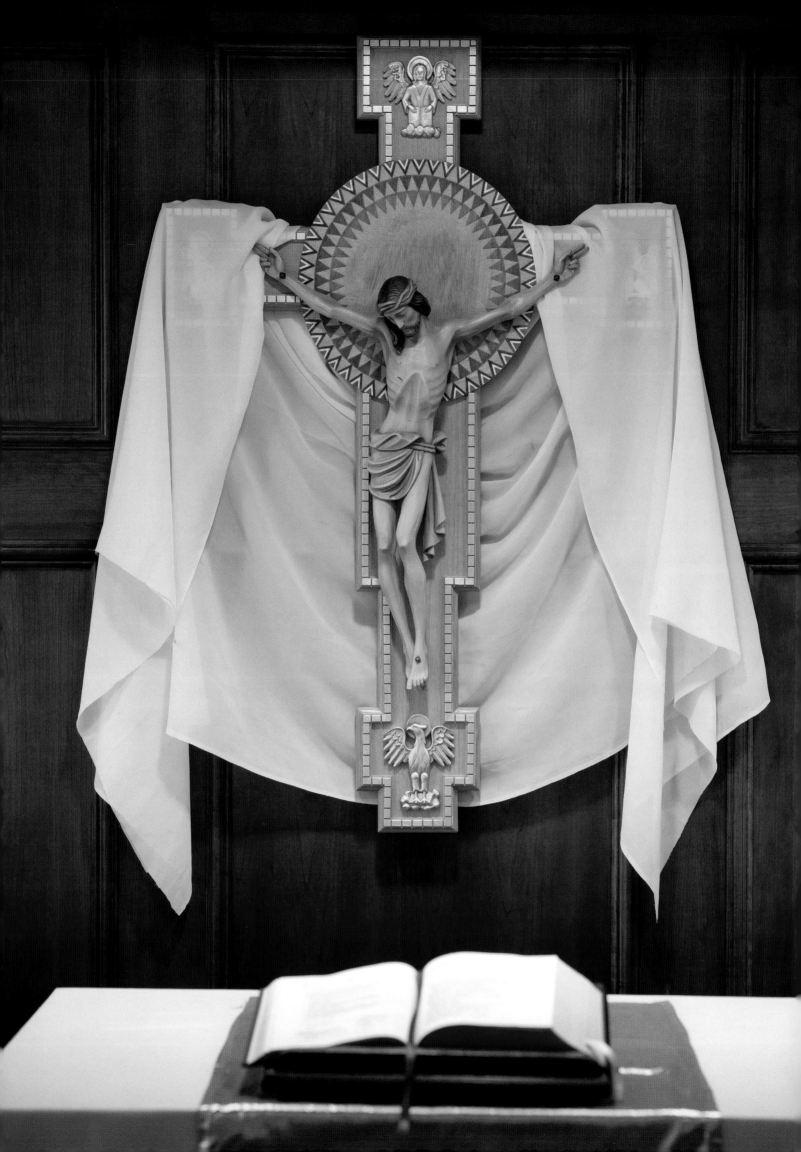

Dedicated to Saint Catherine of Siena (1333?–1380), this chapel was beautifully renovated in 1998. The crucifix behind the altar has the symbols of the four evangelists at each corner. There is an icon of Saint Catherine to the left of the main altar. Saint Catherine's feast day is April 29th. She was named a Doctor of the Church by Pope Paul VI in 1970.

DATE BUILT:
1981

DEDICATION:
Saint Catherine of Siena

ACCESS:
By appointment

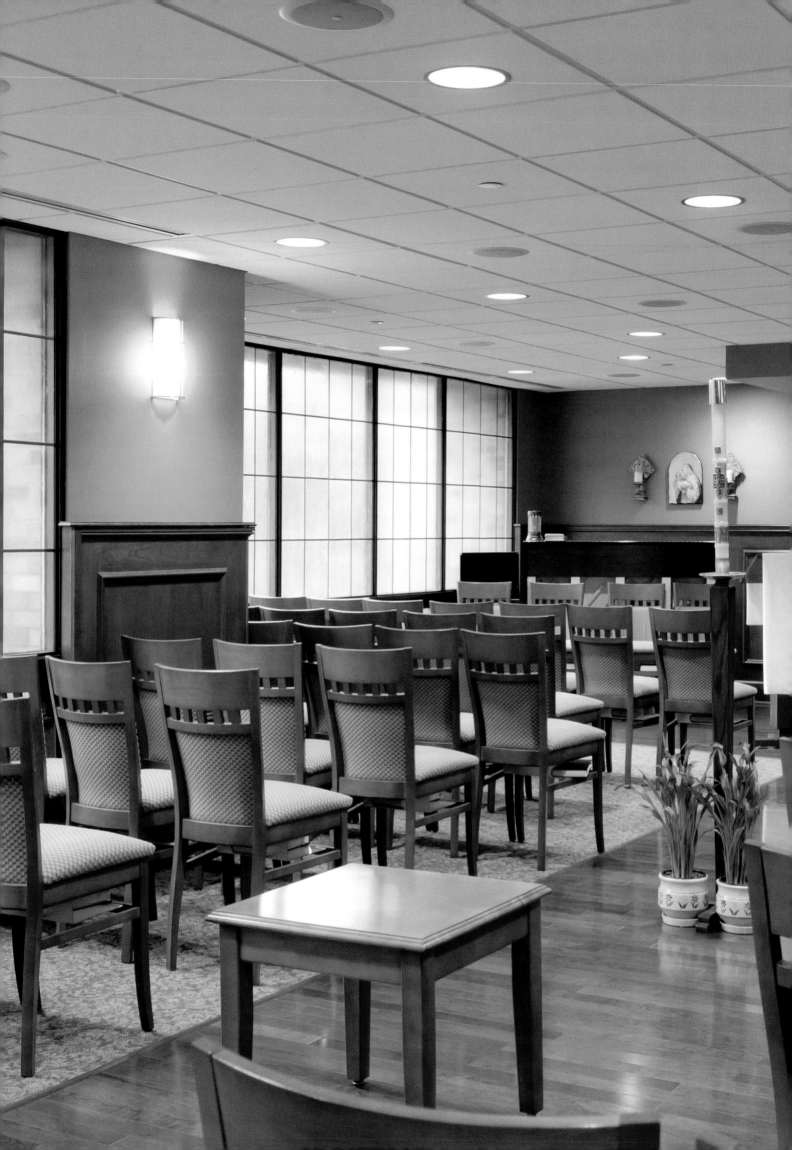

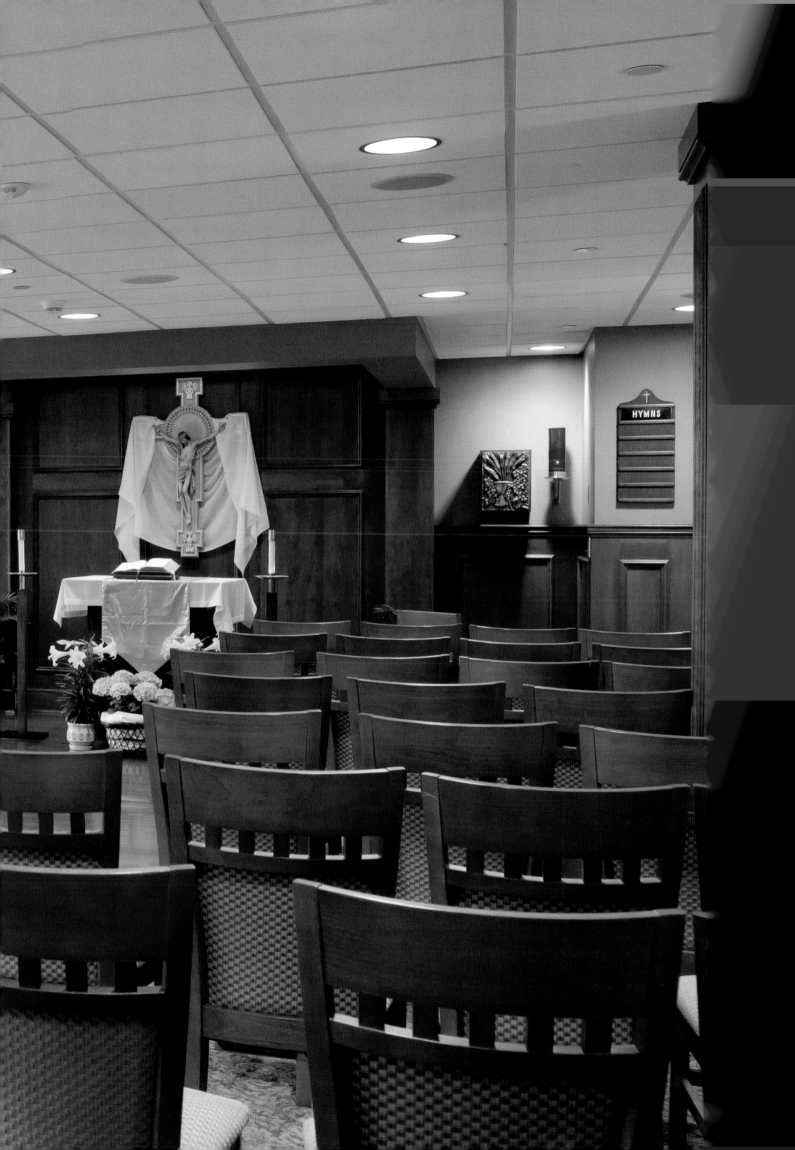

DATE BUILT:
1981

DEDICATION:
Saint Clare of Assisi

ACCESS:
By appointment

Dedicated in honor of Saint Clare of Assisi (1194–1253), the chapel of Pasquerilla West honors the saint with stained glass window panels depicting scenes from the town of Assisi, where she and Saint Francis were both born. The window, in six panels, includes a depiction of the Basilica of Saint Francis, the church in which Saint Francis is buried. A replica of Saint Clare is on the left wall as one enters the chapel. Her feast day is August 11th. She was canonized only two years after her death in 1255. Because of her visionary experiences, she has been named the patroness of television.

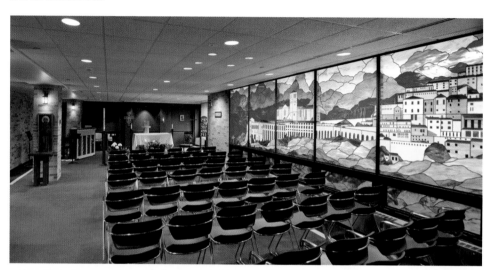

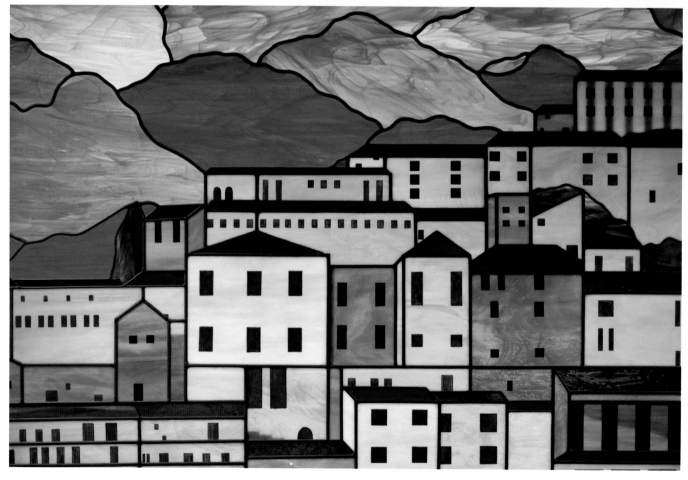

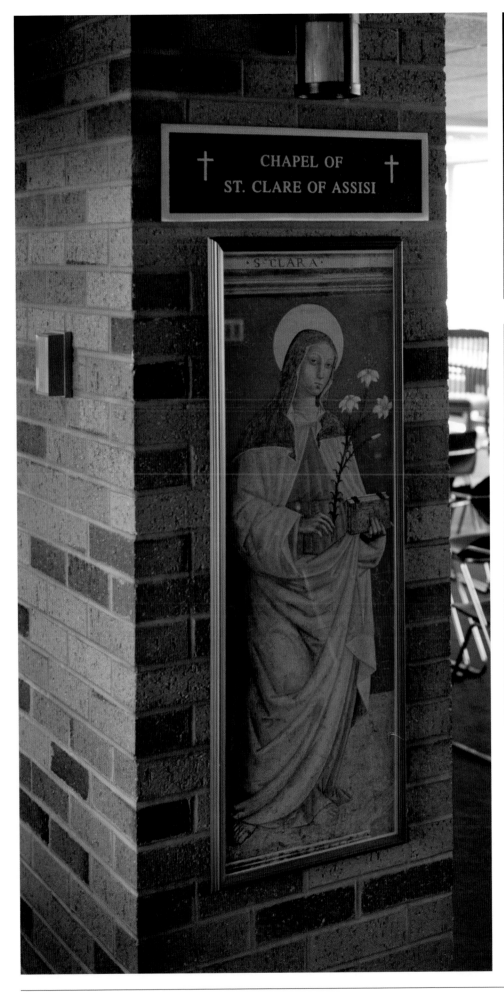

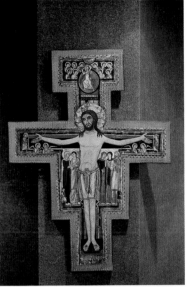

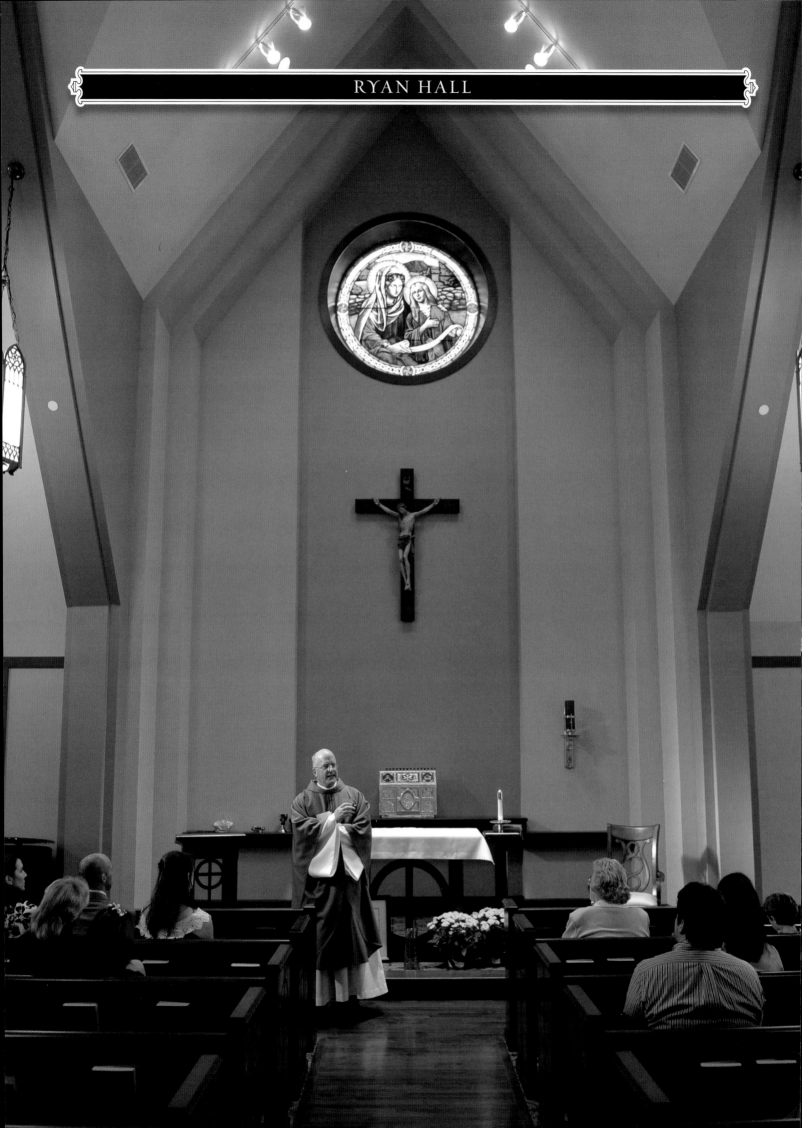

Dedicated in 2009, the chapel of Ryan Hall is dedicated to the mother of the Blessed Virgin Mary, Saint Anne. The oculus window over the main altar depicts Saint Anne instructing the young Mary on how to read. The scroll they are holding may allude to one of the prophets' description of the coming of the promised Messiah. The stunning tabernacle on the main altar is shaped like a coffer. The chapel has three sections of handsome dark wooden pews. The feast of Saint Anne and her husband Saint Joachim is celebrated on July 26th.

DATE BUILT:
2009

DEDICATION:
Saint Anne

ACCESS:
By appointment

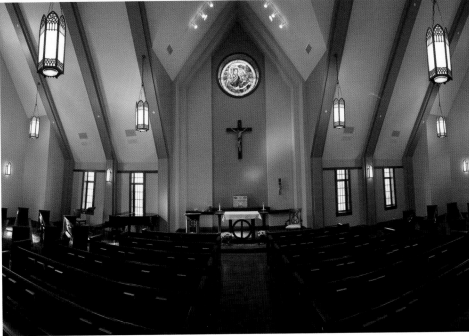

Saints Anne and Joachim are not mentioned by name in the New Testament but do appear in the non-canonical Gospel of Saint James in the second century. Veneration of Saint Anne was widespread in both the Christian East and West. Saint Anne's feast day was enrolled as a universal feast in the Roman calendar by Pope Pius IX in 1854.

DATE BUILT:
1882

DEDICATION:
Saint Edward the Confessor

ACCESS:
By appointment

The building itself dates to 1882 and first served as a residence for the "Minims" (the youngsters who were in primary school). The chapel is dedicated to Saint Edward the Confessor to honor the memory of Rev. Edward Sorin, C.S.C., the founder of Notre Dame. The famed football coach, Knute Rockne, made his First Holy Communion in the chapel on November 1, 1925, along with his young son, who was a Minim. Rockne had been baptized the day before in the Log Chapel.

The windows in the chapel were designed by the same nineteenth-century Carmelite Sisters in France who designed the windows in the Basilica.

Saint Edward
the Confessor
(1003–1066) was the
king of England who,
in his own lifetime,
had a reputation
for holiness. He is
considered the founder
of Westminster Abbey,
and he is depicted in
the famous Bayeux
Tapestry. Saint
Edward's feast day
is October 13th.

DATE BUILT:
1988

DEDICATION:
Our Lady, Seat of Wisdom

ACCESS:
By appointment

Dedicated to Our Lady, Seat of Wisdom, this attractive chapel was dedicated in 1988. Of particular interest is the wood polychromed statue of Our Lady holding the Child Jesus, which is found in a niche in the back of the chapel. The statue is on permanent loan from the Snite Museum of Art. It is thought to be originally from Perugia (Italy); the museum dates it to the late twelfth century.

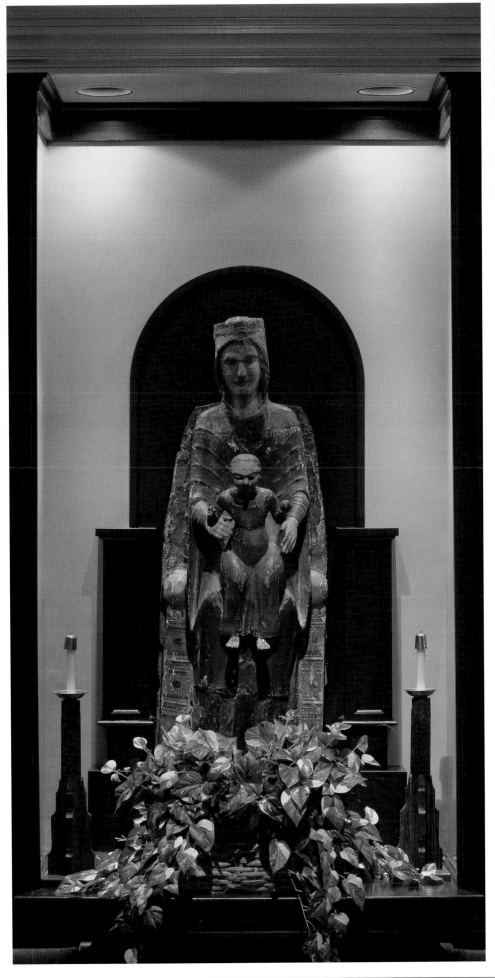

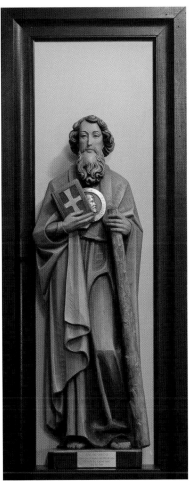

DATE BUILT:
1889

DEDICATION:
Saint Thomas Aquinas

ACCESS:
By appointment

Also known as Sorin College, the building was constructed in 1888 and dedicated a year later. Originally known as "Collegiate Hall," it was renamed "Sorin" to honor Rev. Edward Sorin, C.S.C., at the time of his golden anniversary of ordination. The chapel is dedicated to Saint Thomas Aquinas. As President Emeritus Father Monk Malloy tells it in his book *Monk's Tale: Way Stations on the Journey*, "Since 1979 when I moved into the dorm, it [the chapel] has been completely renovated. Stained glass windows designed by Notre Dame art professor Robert Leader were installed, the pews were refinished, new Stations of the Cross designed by Father Jim Flanigan were placed on the walls, [and] the altar and tabernacle area was reconfigured."

Undergraduate brothers John and Michael Shea, residents of Sorin, composed the "Notre Dame Victory March" in 1908, rehearsing the melody for the first time on the Basilica organ.

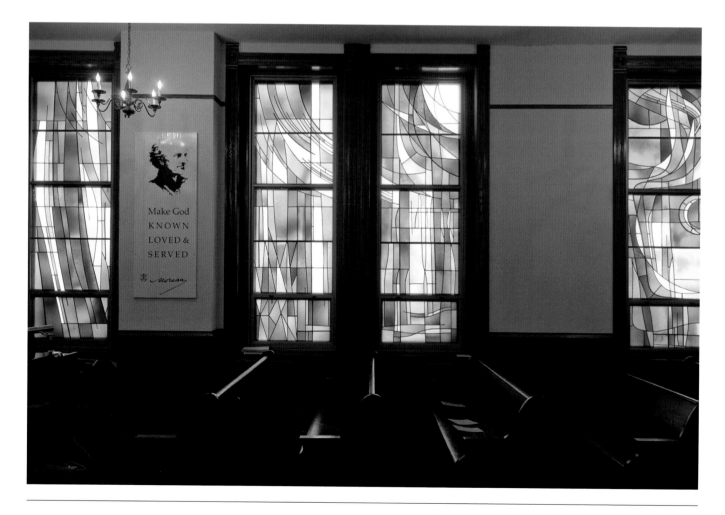

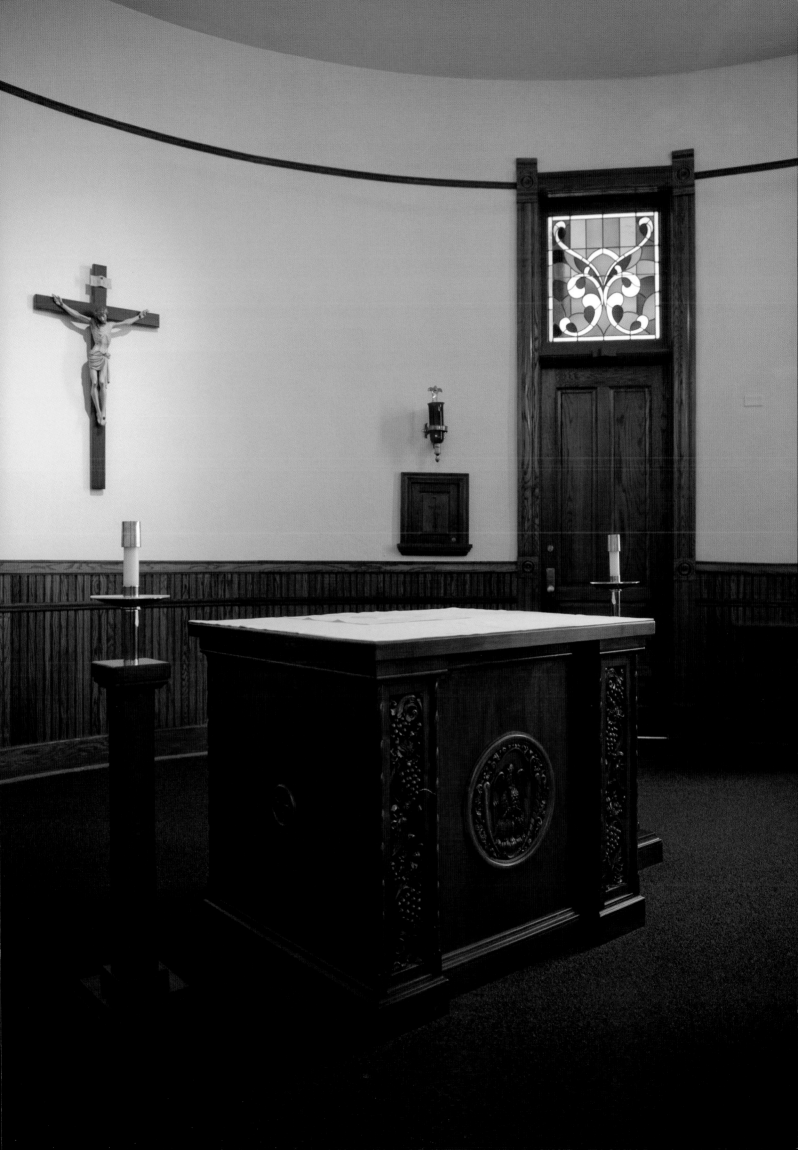

DATE BUILT:
1997

DEDICATION:
Holy Family

ACCESS:
Open

The community center at University Village, the apartment complex for married students, houses a small chapel that was dedicated in 1997 to the Holy Family. Each Sunday, the chaplain of the Village celebrates Mass in the main hall for the residents and guests. The chapel itself reserves the Blessed Sacrament.

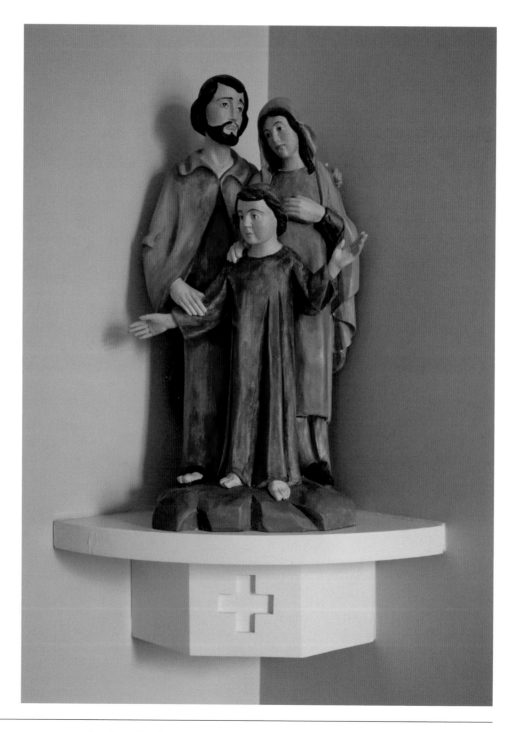

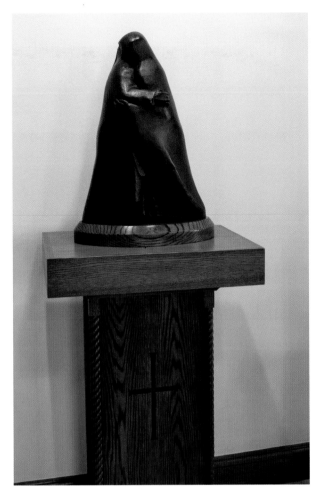

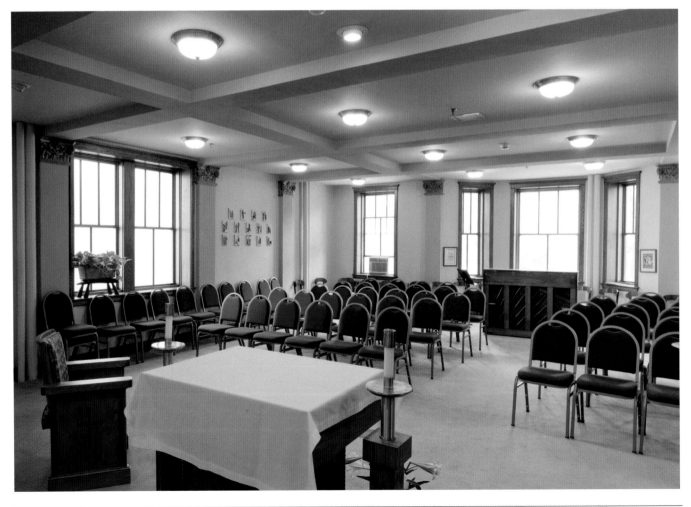

Built in 1909 to honor Rev. Thomas E. Walsh, C.S.C., who was the University of Notre Dame's president from 1881 to 1893, Walsh Hall became a women's residence in 1972 when the university first admitted undergraduate women. The chapel is dedicated to Our Lady of the Visitation. It is one of the plainest chapels on campus, with stark white walls and plain windows. To the left of the main altar is a sculpture of the Visitation of Mary to Elizabeth (Luke 1:39–56), which is a smaller cast of the much larger original done by the late Rev. Anthony Lauck, C.S.C., located outside the entrance of the Hammes bookstore on campus. The feast of the Visitation is celebrated on the 31st of May—a fitting end to the month dedicated to Our Lady.

DATE BUILT:
1909

DEDICATION:
Our Lady of the Visitation
(originally Saint Paschal Baylon)

ACCESS:
By appointment

The Walsh Hall chapel was originally under the patronage of the Spanish Franciscan lay brother saint, Paschal Baylon (1540–1592), who is the patron saint of Eucharistic adoration.

DATE BUILT:
1997

DEDICATION:
Saint Kateri Tekakwitha

ACCESS:
By appointment

Welsh Family Hall and its chapel were dedicated in 1997, with the chapel placed under the patronage of Saint Kateri Tekakwitha (1656–1680), a Native American known as the Lily of the Mohawks. The framed image of Saint Kateri, located just outside the chapel doors, was a gift of the postulator who guided the case for her sainthood. There is a beautiful statue of the saint mounted on the wall to the left of the main altar. She was beatified by Blessed John Paul II in 1980 and canonized in 2012.

> *"Tekakwitha" in Kateri's native tongue means "one who walks groping her way"—an allusion to the near blindness she experienced as a result of the smallpox that ravaged her people. "Kateri" is a version of the name "Catherine."*

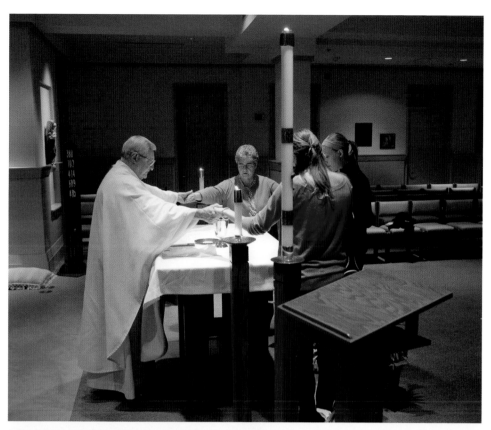
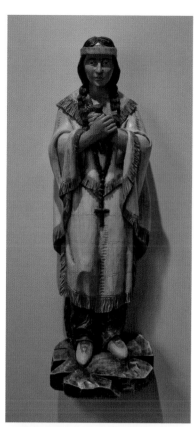
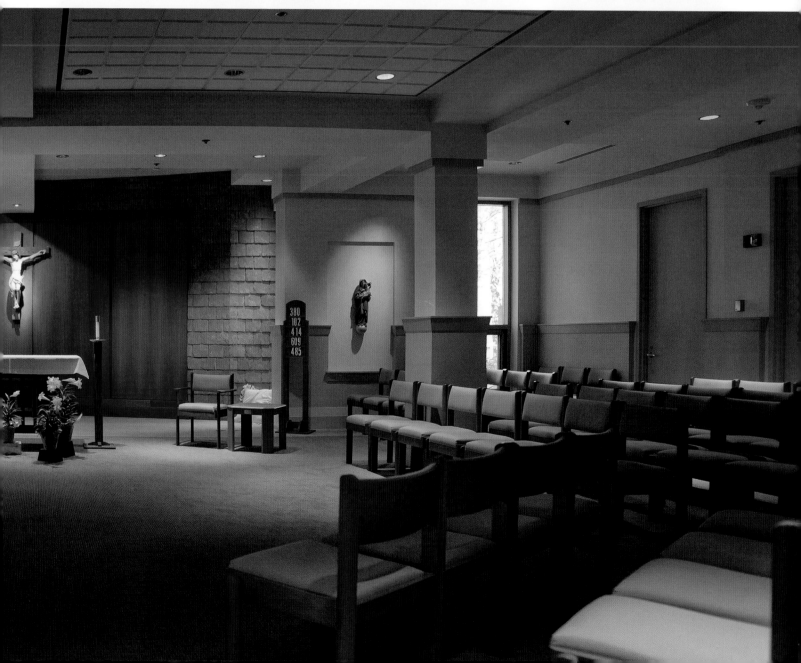

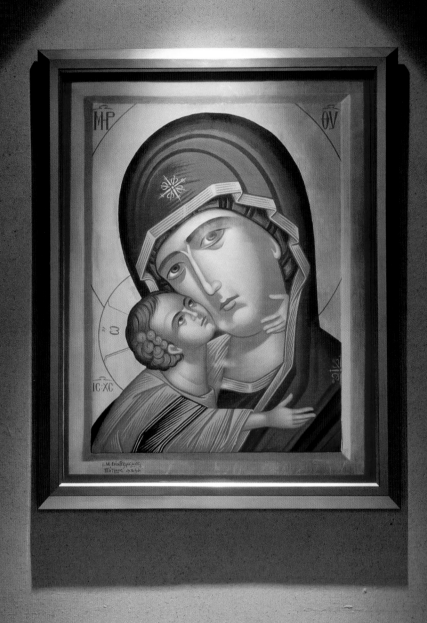

Built in 1937, Zahm Hall is dedicated to the great Dominican thinker Saint Albert the Great, the teacher of Saint Thomas Aquinas. The main altar has a Latin inscription that reads in translation, "Behold the Bread of Angels which becomes the food of pilgrims," while the altar of repose has the inscription "In our midst let Christ God be." To the left of the main altar is an altar dedicated to Our Lady with an icon of Mary holding the Christ Child. In a niche in the back of the church is a statue of Saint Albert the Great.

DATE BUILT:
1937

DEDICATION:
Saint Albert the Great

ACCESS:
By appointment

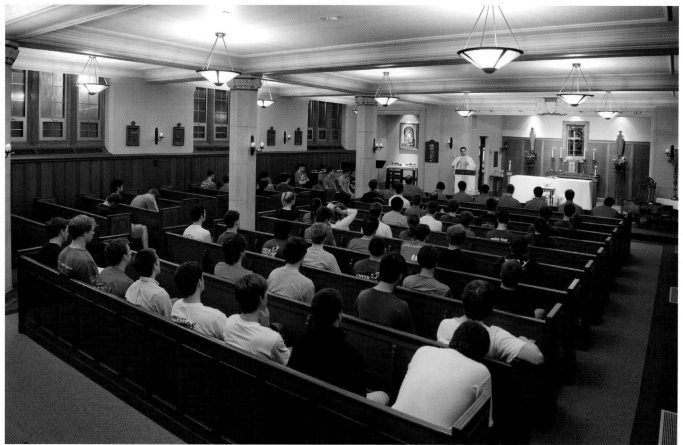

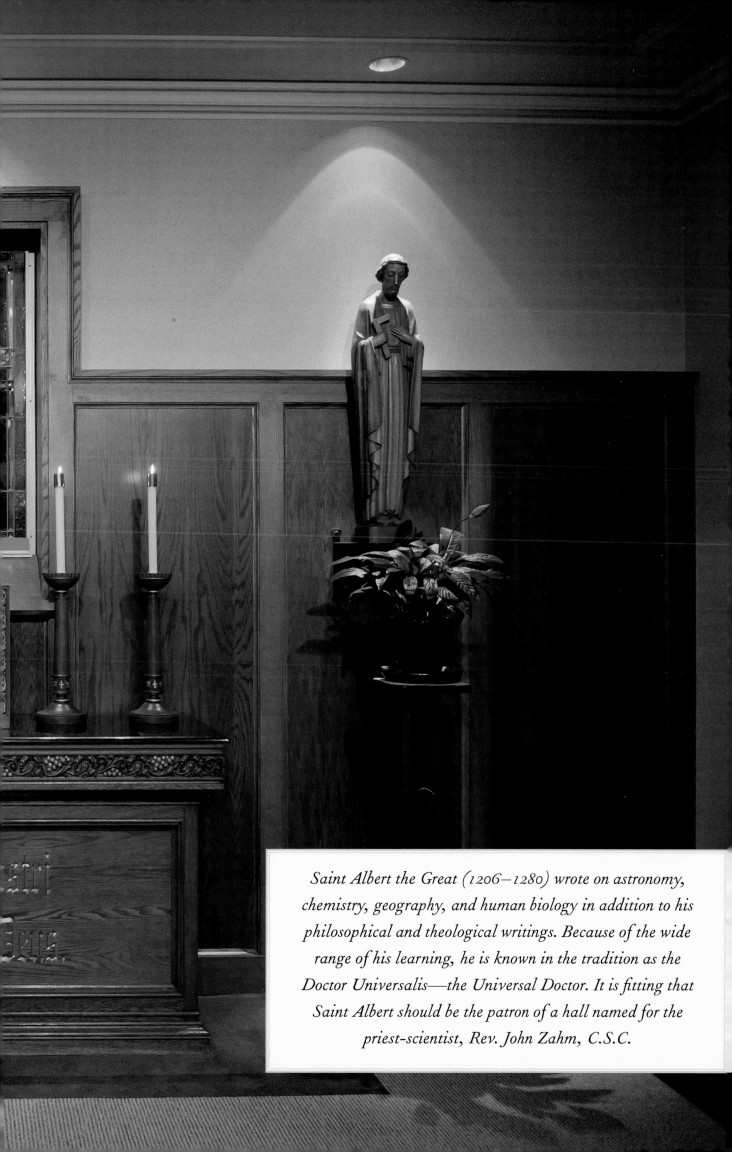

Saint Albert the Great (1206–1280) wrote on astronomy, chemistry, geography, and human biology in addition to his philosophical and theological writings. Because of the wide range of his learning, he is known in the tradition as the Doctor Universalis—the Universal Doctor. It is fitting that Saint Albert should be the patron of a hall named for the priest-scientist, Rev. John Zahm, C.S.C.

While the entire campus is under the protection of Our Lady, there are times when the campus itself becomes the locus of spiritual experience. People walk the lakes while praying and meditating and, not infrequently, one sees students and others under the canopy of the trees in small prayer groups. At times, groups will pray and stand vigil for some particular cause, like those moments when students and staff engage in solidarity for Life or for the homeless. Official liturgical events sometimes cross the campus, such as the procession on Palm Sunday or the annual Corpus Christi Procession. Those who were privileged to attend will recall the vast congregation that assembled on the South Quad for Mass on the afternoon of the September 11th tragedy. Most visitors, of course, will seek out the hallmark campus spot on Notre Dame's campus: the Marian grotto behind the Basilica of the Sacred Heart.

Notre Dame's sacred spaces are not limited to its main campus in Indiana. The University of Notre Dame's commitment to international education not only means that students and faculty regularly study and teach abroad in nearly thirty different locations around the world, it also owns three campus centers: in Dublin (Ireland), in London (England), and in Jerusalem at its Tantur Ecumenical Institute. All three of these centers, following the Notre Dame custom, have chapels. Dublin's chapel is dedicated to Saint Patrick; London's chapel is dedicated to Notre Dame Our Mother; and Tantur is unique in that its unnamed chapel is self-consciously ecumenical with Mass celebrated there on a regular basis.

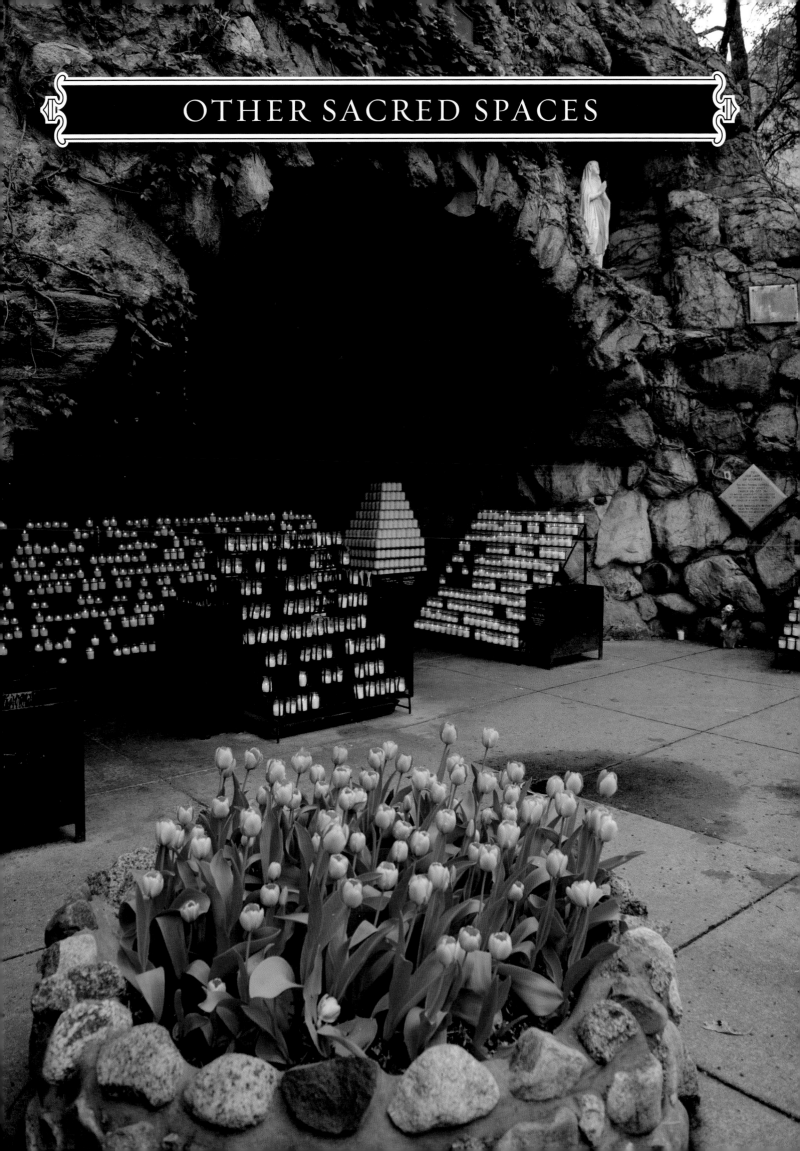

OTHER SACRED SPACES

Saint Patrick's Chapel is located in O'Connell House, which hosts the Keough-Naughton Notre Dame Centre. The Georgian house dates back to the 1790s and was the home of the early nineteenth-century Irish Catholic political leader Daniel O'Connell. Notre Dame acquired O'Connell House in 2002 and officially dedicated it in 2004. The chapel features a beautiful stained glass window that was based on a Harry Clarke design, as well as a copy of a medieval book plaque by the sculptor Colm Brennan and calligraphy by Tim O'Neill.

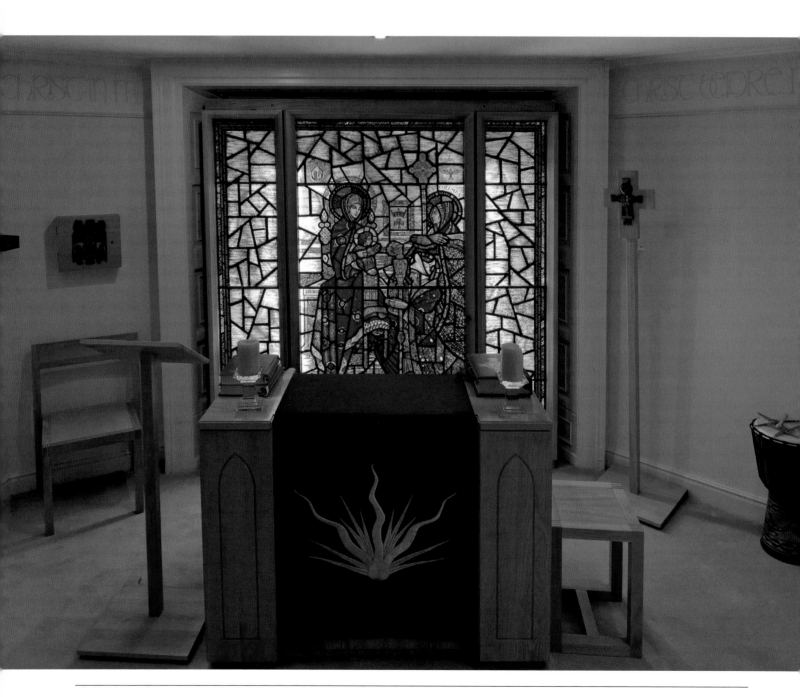

Conway Hall, a residence hall for students in the Notre Dame London Program, was officially opened in 2011 and dedicated in 2012. The historic building containing the hall is Royal Waterloo House, originally a children's hospital. Conway Hall's chapel is dedicated to Notre Dame Our Mother. A weekly Mass is celebrated in the chapel on Sundays.

Photograph by Jordan Rosenhaus

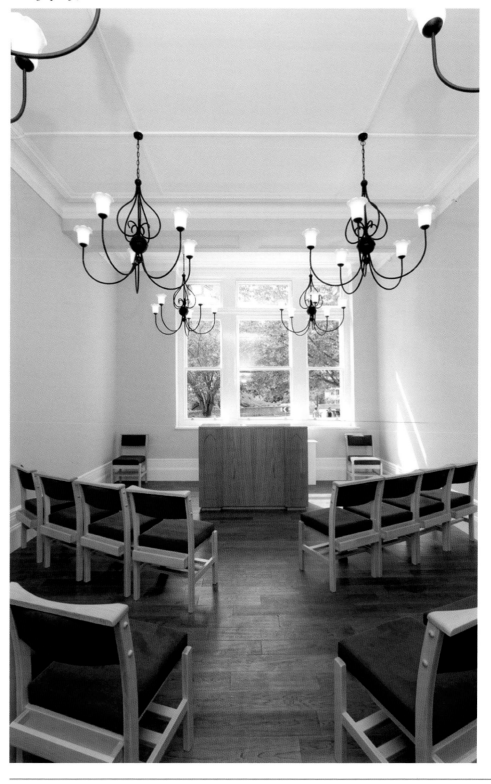

The Notre Dame London Centre's building on Trafalgar Square, which is leased by the university, also has a chapel that is used by participants in the university's various London programs. This chapel has the Blessed Sacrament reserved, and it is dedicated to Saint Anselm.

The Tantur Ecumenical Institute opened in 1972. The program participants—who generally include Roman Catholics, Anglicans, and Orthodox and Protestants of various traditions—live, study, and pray together. Tantur's unnamed chapel is simple and unadorned, except for a few moveable icon stands, in keeping with its ecumenical nature. Mass is celebrated in the chapel on a regular basis, and the Blessed Sacrament is reserved in a separate room for prayer and Eucharistic adoration.

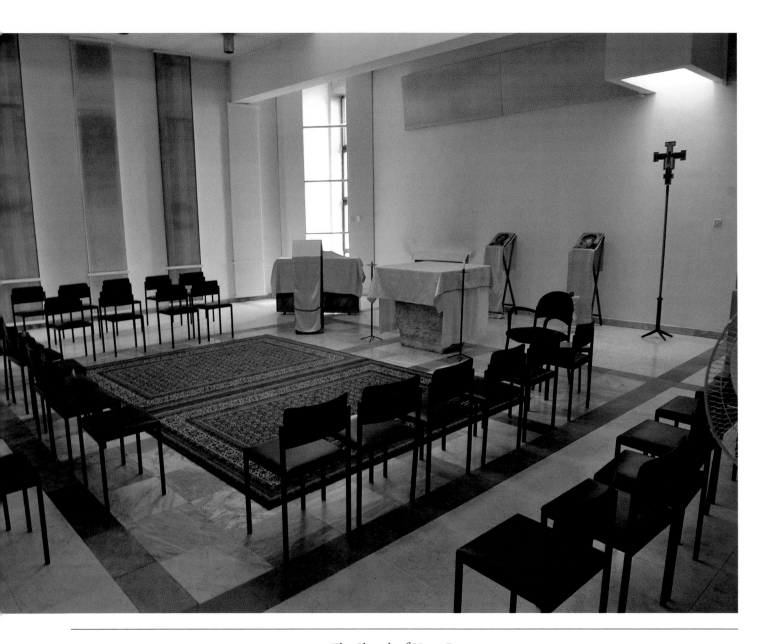

While the Grotto is not technically a chapel, it is one of the most familiar and most loved sacred spots on campus. Built in 1896 under the direction of Rev. William Corby, C.S.C., to honor Our Lady, it is a replica of the Grotto of Massabielle near Lourdes in France where Our Lady appeared to Saint Bernadette in 1858. The funds to build the Grotto were a gift from Rev. Thomas Carroll, who had once been an undergraduate at Notre Dame.

Seniors at Notre Dame make a traditional "last visit to the Grotto," most weddings celebrated on campus include a picture in front of the Grotto, and many people can be found praying there at any time (especially students before examinations). So many candles are left by visitors that the fire department at Notre Dame must be alert lest the grotto area catches fire, as it has done a few times in the past, from the accumulated carbon ash deposited on the rocks. Every evening at 6:45, the rosary is recited in its precincts, and Mass is celebrated on special occasions at the outside altar that stands to the right of the shrine itself.

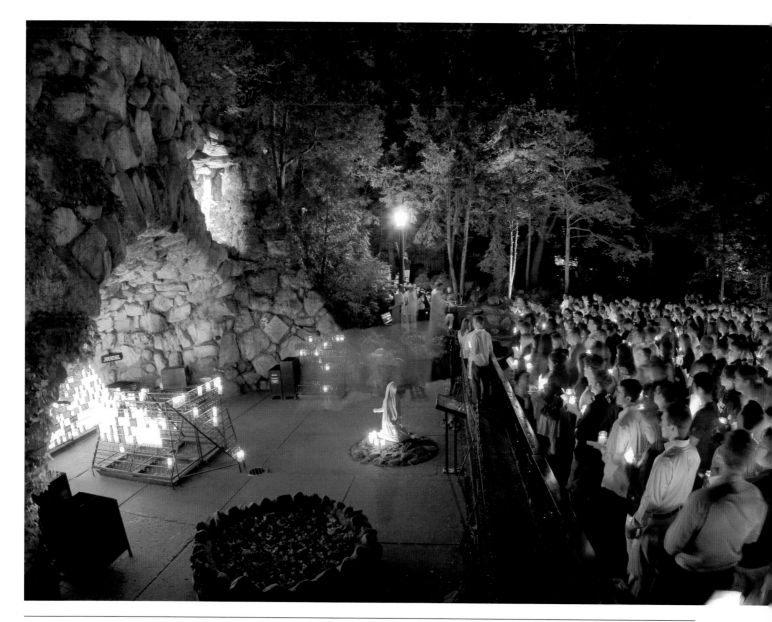

From its origins, the University of Notre Dame has attempted to fulfill the ancient Catholic truth that we know God through reason and faith. Faith, of course, is not merely something that is affirmed; it is also performed. This beautiful book illustrates many of those places on our campus where faith is performed in its formal worship as well as in its informal prayers and devotions.

The chapels on the campus of Note Dame are a visible testimony to our common Catholic faith; a lasting reminder of the generosity of our many benefactors; and an iconic tribute of that beauty coming from human hands as a reflection of the source of all beauty—God.

As president of the University of Notre Dame, I am profoundly grateful to those who proposed this volume and those who saw it through to final realization. May their good intentions and many labors be a blessing on all who read it.

REV. JOHN I. JENKINS, C.S.C.

PRESIDENT